May 2, 2000

Thank you for joining us in New York for our tour and c... The Guggenheim ... dinner at LeRefuge... We appreciate you... loyalty and support of our firm.

The Garibaldi Group

D0567406

Claude Monet

BY CATHERINE MORRIS

THE WONDERLAND
PRESS

Harry N. Abrams, Inc., Publishers

THE WONDERLAND PRESS

The Essential™ is a trademark
of The Wonderland Press, New York
The Essential™ series has been created by The Wonderland Press

Series Producer: John Campbell
Series Editor: Julia Moore
Project Manager: Adrienne Moucheraud
Series Design: The Wonderland Press

Library of Congress Catalog Card Number: 99-73512
ISBN 0-7407-0289-0 (Andrews McMeel)
ISBN 0-8109-5802-3 (Harry N. Abrams, Inc.)

Terrace at Sainte-Adresse. The Metropolitan Museum of Art
(67.241) Photograph © 1989 The Metropolitan Museum of Art

The Four Poplars. The Metropolitan Museum of Art. Bequest of
Mrs. H.O. Havemeyer, 1929. Photograph © 1999 The Metropolitan Museum of Art

Unless caption notes otherwise, works are oil on canvas

Printed in Hong Kong

Harry N. Abrams, Inc.
100 Fifth Avenue
New York, NY 10011
www.abramsbooks.com

Contents

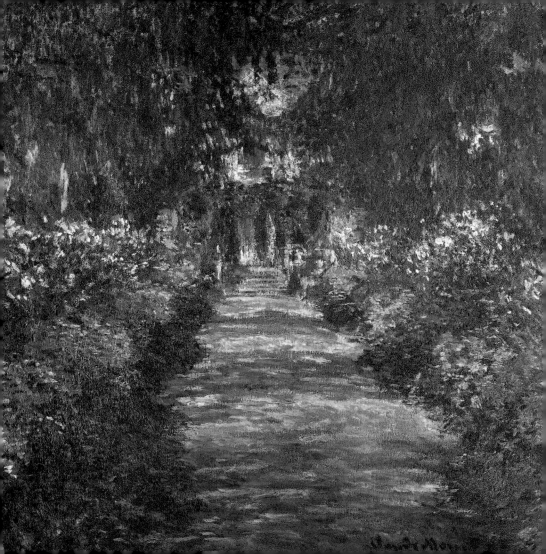

The Essential Claude Monet

Is there any painter in the history of art who is more **popular** than the Impressionist master Claude Monet? His almost 2,000 paintings, produced over a seven-decade career, sell for tens of millions of dollars; his exhibitions draw staggering crowds; his works can be found everywhere, lovingly reproduced in art books and (less lovingly?) on everything from coffee mugs, framed posters, and greeting cards to dinner sets and beach towels; his garden and home in Giverny are an art-world Mecca that draws hordes of tourists annually.

In short, *Monet is hot!*

But why? It's impossible to imagine that his delicate evocations of flower gardens, lily ponds, and the French countryside originally took place at the center of **one of the art world's biggest and most shocking scandals.** At first sight, many conservative Parisians hated the Impressionists with a passion that sounded as a war cry. *Critics called Impressionism a sickness*, and one of them noted that a particular Monet sun didn't so much look like the sun as it did a tomato! The term *Impressionist* itself was coined in a satirical piece by a columnist who derided the painters' techniques and philosophies of light, vision, and color. So much for predicting the future!

The powers that drove the French art world convinced the guileless public that looking at Impressionist pictures could make you insane—or,

OPPOSITE
*Footpath in
the Garden*
1902
35 x 36 $\frac{1}{4}$"
(78.75 x 81.6 cm)
Kunsthistorisches Museum, Vienna
Nimatallah/Art Resource, NY

at the very least, feel queasy. This wasn't just bad art, they protested; it was a menace to standards of taste, and, ultimately, to French culture.

If all of the above were true, the question to ask might be: How did the public perception of Monet change, with time, from that of a repellent avant-garde hack artist to one whose works are universally and unconditionally beloved in the 21st century?

Sound Byte:

"What I need most are flowers, always."

—CLAUDE MONET, 1919

OPPOSITE
Detail from
*Water Lilies
Green Reflections
(Central Part)*
n.d.
Musée de l'Orangerie, Paris
Giraudon/Art Resource, NY

Natural-Born Impressionist

Seven decades after his death, Monet stills holds the Über-Impressionist crown. His works far surpass those of Renoir and Degas as crowd pleasers and major stars on the auction circuit. In fact, the arc of his career aligns so closely with the course of the Impressionist movement that the two parallel each other, decade by decade:

- The seeds of the Impressionist movement can be found in the 1860s, when Monet met the artists **Camille Pissaro** (1830–1903), **Pierre-Auguste Renoir** (1841–1919), **Alfred Sisley** (1839–1899), and **Frédéric Bazille** (1841–1870).

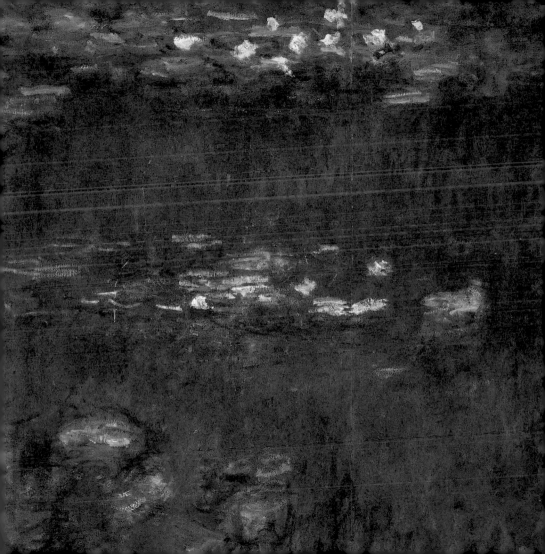

- Monet was a driving force in defining Impressionism and in popularizing the movement, whose heyday was the 1870s.

- In the 1880s, as the Impressionist artists became more known for their differences than their similarities, Monet distanced himself from the group while maintaining a staunch commitment to the movement's first principle of painting directly from nature.

- During the 1890s, when the movement was generally considered dull, *passé,* and spiritless, Monet staged his own one-person offensive (which he called "campaigns"), painting the haystacks, poplars, and cathedral façades that would show the world Impressionism's complexity and vitality.

- Through the first three decades of the 20th century (the last ten years of which Monet was infirm and almost blind), he worked faithfully at Giverny on his huge waterlily canvases—his *Grandes Décorations* that become the culminating masterpieces of the Impressionist style.

A Quick Intro to Impressionism

Before we get too far into the discussion of Monet, let's clear up a few common misconceptions about Impressionism. In addition to Monet, Renoir, and Sisley, the most important French Impressionists are **Edgar Degas** (1834–1917), **Berthe Morisot** (1841–1895), and

Camille Pissarro (1830–1903), even though many of their works are not considered Impressionist. (**Édouard Manet**, 1832–1883, is often called the "Father of Impressionism.") The Impressionists' goal was to depict contemporary life in a spontaneous way by painting "impressions" of what the eye *sees*, rather than what the mind *knows*. To achieve this goal they:

Édouard Manet photographed by Nadar, c. 1864

- worked outdoors, painting in natural light;

- painted quickly to capture the fleeting experience of light and vision;

- portrayed intense light and bright colors as they appear in nature;

- combined painting and drawing in a way that made composition and color equally important and immediate.

A "catch-all" name

Impressionism was never the cohesive formal movement that this laundry list implies. For example, Monet's intuitive approach to painting nature and light was at odds with Degas' acutely studied renderings of contemporary urban (and indoor) subjects, such as his scenes from bars and ballet studios. The commonly noted features of Impressionism describe the habits of the *Impressionist landscape painters*. With Monet as the star of this subgroup of landscape artists,

OPPOSITE
Detail from
Chrysanthemums
1897
36 x 52"
(80 x 117.5 cm)

Visual Arts Library/
Art Resource, NY

it is accurate to point out that *most descriptions of Impressionist style are actually descriptions of Monet's style*, rather than of any kind of theoretical Impressionism. One reason, for example, that the Impressionist painters were grouped together was because they exhibited their works as an ensemble, not because of any uniformity of painting styles.

A 19th-century Spin Doctor

Monet's creativity extended to the realm of fabricating the details of his life. What we know of Monet's early life and career come from some interviews conducted with him in his later years after he had become internationally famous. He changed the facts of his life at will and told stories that were sometimes erroneous, as with his claim that nature was the *only* studio he had ever had.

In one sense, this spin-doctoring is understandable. After becoming a celebrity, Monet was *besieged* by people wanting to know everything about him. By this stage, he was aware of his great reputation and saw his life as a heroic struggle, so he edited and embellished events to support the epic view of his fight for the cause of Impressionism. When it comes to his own comments and quotes, including the Sound Bytes in this book, there's one thing to remember: *Reader beware!* But regardless of its mythmaking (a popular activity with many artists, in fact), Monet's story describes how a man gifted with talent and ambition forever changed art history and changed the way we look at art.

Earliest Childhood

And so the story begins: Oscar-Claude Monet is born in Paris on November 14, 1840, the second son of 40-year-old **Claude-Adolphe Monet** (1800–c. 1871) and his 35-year-old wife, **Louise-Justine** (1805–1857). When Oscar is about five (he will be called Oscar until he reaches his early twenties), the family leaves urban Paris for the town of Ingouville, a suburb of Le Havre on the coast of Normandy, in northwestern France. Captivated by nature, the sea, and the unpredictable weather typical of the area, the youth spends much of his childhood wandering the local shores and finding inspiration for his first drawings in the local harbors and in the estuary of the Seine River. When Claude-Adolphe takes a job in the wholesale grocery business of his half-sister's husband, the family settles into a mid-19th-century bourgeois lifestyle. (His father's half-sister, **Marie-Jeanne Lecadre**, 1790–1870, will play a vital role in Monet's life.)

School Years and the Death of His Mother

In 1851, Oscar begins his formal education as a student at the Le Havre high school, where he studies drawing with a local artist named **Jacques-François Ochard** (1800–1870). The young student, showing early promise, fills notebooks with sketches of boats and landscapes—a mere glimpse of what will follow in his career—and caricatures of people he observes. Years later, Monet admits to having been an unruly student ("I

could never bend to any rule, even as a very small child") and compares the school to a prison that couldn't contain him. School records tell a more benign story, claiming that little Oscar is an affable and amiable pupil.

Tragedy strikes when **Oscar's mother dies on January 28, 1857**, when the boy is 16. Grief-struck, Oscar leaves school forever, despite his father's protests. Marie-Jeanne Lecadre, his childless aunt (who will become a widow in 1858), takes over the daily responsibilities of raising him—an event of tremendous good luck for the adolescent. An amateur painter in her own right, the sympathetic and wise Marie-Jeanne encourages her nephew's talent while pacifying the disapproval of Oscar's controlling father. (She is sometimes called Tante Lecadre, since "tante" is French for "aunt.")

Family Values

While neither rich nor cosmopolitan, Oscar's family has firmly entrenched goals and ambitions, and Claude-Adolphe expects his son to plan his life according to middle-class rules of prosperity and social acceptance. By and large, Oscar embraces this thinking, but not at the expense of his budding artistic ambitions.

For decades, Oscar will struggle with the challenge of figuring out how to reconcile his attraction to material and physical comforts with his desire to be an artist. Even dead-broke, he will love nothing more than a shopping spree, accompanied by a lifelong habit of wheedling his

Claude Monet at age 20, in 1860

more prosperous (or less spendthrift) friends for charitable donations. Since it will be decades before his income matches his penchant for spending, Monet will often live life just one step ahead of his creditors.

Having fun with Sketches

In 1856, **Oscar enters the commercial art world as a precocious teenager** when his caricatures of Parisian social figures and the townspeople of Le Havre appear in the windows of a local frame shop. (Before there were galleries, there were frame shops.) Displaying the classic features of this 19th-century pop-culture genre, Oscar's caricatures (signed "O. Monet") are witty, sly, and barbed. In one of them, the notary Léon Machon stands among advertisements for his trade services, sporting an enormous head with an exaggerated face (huge nose, muttonchop sideburns, full lips, big eyes, a high forehead, and an elaborate side curl), atop a sketch of a proportionally much smaller body.

The Art Institute of Chicago

Léon Machon
Notary. c. 1856
Charcoal height-
ened with white
chalk. 24 x 17 ⁷/₈"
(54 x 40 cm)

> *FYI:* **Paint in tubes**—In the 1840s, the big news for painters was the development of portable equipment and commercial paint in metal tubes. Freed from the confines of working exclusively in the studio, where they once had to mix their own paints, artists could now pack up their supplies and head outdoors to work.

An early influence

Soon after his caricatures appear in town, Monet meets the painter
Eugène-Louis Boudin (1824–1898), who also shows at the frame
shop. Boudin is the son of a local sailor who paints outdoors, claiming
that "everything that is painted directly and on the spot always has a
force, a power, a vivacity of touch that cannot be re-created in the stu-
dio." Monet has drawn outdoors since childhood and agrees to accom-
pany the older artist on a painting trip to nearby Rouelles, where they
set up easels and paint *en plein air* ("in the open air").

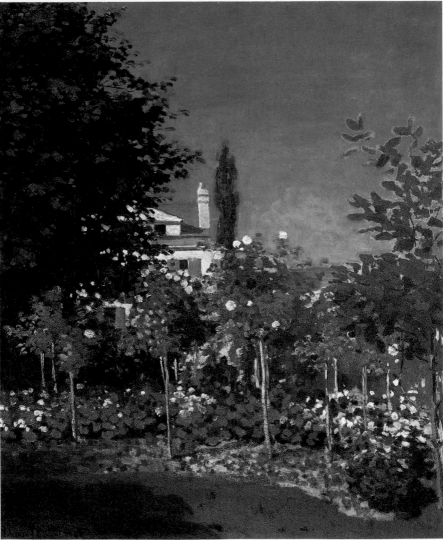

The excursion with Boudin is a real eye-opener: To his great delight, Monet discovers that he loves the immediacy of painting directly from nature. He is challenged by the intensity of the activity and enjoys the concentration required to capture a subject quickly, before the light and weather change. Thus, one might suggest that the seeds of Monet's Impressionism can be traced to this simplest of outings, one fine afternoon in an idyllic country setting.

OPPOSITE
Garden in Bloom
1866–67

Sound Byte:
"I had seen what painting could be…simply by the example of this painter working with such independence at the art he loved. My destiny as a painter was decided."

—CLAUDE MONET, 1900

Bright Lights, Big City

An exuberant Oscar is now committed to painting and decides he must go to Paris. This does not please his father, but what else is new? Once again Tante Marie-Jeanne smoothes the way. While the aspiring painter saves money from his caricatures to pay for a trip, his aunt and Boudin arrange for letters of introduction to be sent to several artists,

including Boudin's friend (and Barbizon painter) **Constant Troyon**. An attempt to get a local grant to supplement his meager savings fails, but in April 1859, the ambitious young artist bravely sets out for Paris to make his mark.

The 18-year-old Monet arrives in the capital just a few weeks after the opening of the annual Salon, where "official" artists exhibit their paintings. Zealously throwing himself into the art scene, Monet spends hours studying the paintings, making the rounds of galleries and studios, and visiting art-world watering holes such as the Brasserie des Martyres.

Sound Byte:
"I am a proud person with a devilish self-esteem."
—CLAUDE MONET, to Alice Hoschedé, 1893

The junior man-about-town offers some advice to his teacher back home. Noting the "complete absence" of seascapes at the exhibition, Monet suggests that Boudin think about tapping into this market, as "it could take him far." Monet tries his hand at drumming up business for the two of them and, in return for his efforts, brazenly asks for a commission: a Boudin drawing. A lifelong habit of professional hustling emerges; he supports and encourages his friends but is even more keen on cultivating his own connections.

A Military Detour

When it comes to business and career building, Monet is pragmatic and clearheaded, heeding Constant Troyon's recommendation to do four things immediately: Learn to draw, work in a productive studio where live models are available, make copies of original artworks in the Louvre museum, and continue to work from nature. In the fall of 1859, he implements this plan, working at a studio called the Académie Suisse, where he meets the painter Camille Pissarro and samples the bohemian lifestyle of Paris.

These career moves, however, are temporarily stymied by the draft. **Monet joins the cavalry in July 1861** and quickly finds himself bound for Algiers as part of the dashing *Chasseurs d'Afrique* regiment. This trip introduces Monet to a country whose clear light and exotic landscape he will never forget. He later claims that "the germ of my future interests emerged in Algeria." Unfortunately, he encounters more than artistic germs in North Africa: Typhoid fever retires Monet from active duty within a year of his arrival.

During his long recuperation in Le Havre, Monet meets the Dutch landscape painter **Johan Bartold Jongkind**

BACKTRACK:
Romanticism and The Barbizon School

The Barbizon artists took their name from the little town of Barbizon, near the forest of Fontainebleau, outside of Paris, where they settled starting in the late 1840s. They included **Jean-François Millet** (1814–1875), **Jean-Baptiste-Camille Corot** (1796–1875), **Théodore Rousseau** (1812–1867), **Charles-François Daubigny** (1817–1878), and **Constant Troyon** (1810–1865). Their landscapes, which they painted with near-religious reverence and in ever-softening light, depict peasant life and the quality of natural light on objects. Though they advocated drawing directly from nature, they were actually studio painters who completed their works indoors, based on voluminous sketches. Their rural images were seen as serenely beautiful antidotes to the ugly modern world.

In the 19th century, the French Académie des Beaux-Arts was the arbiter of all standards and practices in French painting and sculpture. The Academy, which ruled with an iron fist, conformed to rigid principles of taste and to a hierarchy of painting categories: Highly polished history painting and mythological allegories that featured nubile beauties were considered wonderful; dreary barnyard scenes with animals were deemed to be passably acceptable; and highly colored or loosely painted canvases were verboten.

Until late in the century, an artist's survival was virtually dependent on his (or, very occasionally, her) participation in this rigid academic system.

Under pressure to popularize (i.e., loosen up) the annual Salons—which had previously been held solely for the benefit of members of the Academy—the official exhibitions were opened to the public in 1831.

What had once been an exclusive and regimented affair became a carnival-like (and very popular) spectacle. In spite of the Salon's liberated exhibition policies and huge attendance figures, however, an artist's career was still controlled by the authoritative Academy. A rejection or a damning review could be the kiss of death to a young artist.

By mid-century, discontented artists started making serious noise about the repressive nature of the Academy. (Art galleries did not appear on the scene to fill the exhibition and sales gap until much later—right around the time, in fact, that the Impressionist group started showing independently.)

The year 1863 marked a particularly brutal round of rejections by the Academy in which more than half of the 5,000 submissions were dismissed. The government and the art establishment tried to assuage the outcasts by staging an alternative exhibition, called the **Salon des Refusés**, which became a popular diversion unto itself.

The arcane rules of acceptance and rejection were a mystery to anyone outside the system. Napoleon III himself claimed he could not see much difference between the accepted and rejected pieces. Thus, a fine-arts counterculture was established in France.

(1819–1891), who, in addition to Boudin, popularizes outdoor painting along the channel coast. Although he had disparaged Jongkind's work in the 1859 Salon (writing to Boudin that Jongkind was "dead to art"), Monet becomes indebted to the older man's generous guidance, claiming years later that Jongkind was his true master ("I owe to him the final development of my painter's eye").

The 1860s: Infancy of Impressionism

Itching to get back to Paris, Monet makes a concession to his cautious father and aunt by joining the respectable workshop of **Charles Gleyre** (1806–1874), a painter of popular but bland romantic figures and landscapes. Though he would later disparage the workaday Gleyre, Monet soon finds that being at the atelier in 1862 and 1863 turns out to be much more than just a day job:

- The master turns out to be a sympathetic and encouraging teacher.

- Monet's fellow students—Renoir, Sisley, and Bazille—share his artistic interests.

The four aspiring artists form a painter's "rat pack," working side by side in the Louvre, and taking weekend painting junkets to small towns on the outskirts of Paris and in Normandy. Painting together in the Barbizon territory of Fontainebleau, the younger artists conscious-

ly take up the themes and locales of their idols—and promptly change the rules by painting scenes that, instead of wrestling to capture, for example, the *treeness* of trees, attempt to understand how light affects the artist's *perception* of the trees.

Out of The Frying Pan and...

Frédéric Bazille

By early 1864, Monet, Renoir, Sisley, and Bazille have all abandoned Gleyre's studio. Monet spends time in Paris and also returns to his old haunts, painting in Fontainebleau and on the channel coast. While in Paris, he takes advantage of his friend Bazille's generosity and works in the latter's studio. (Having a supportive and prosperous businessman for a father puts Bazille in a position to help his economically less fortunate friends. But stay tuned: *This gets awkward later.*)

It's a good thing **Monet has some generous chums** at this time, since he hesitates to take that most important first step toward professional status—submitting to the Salon and getting paid for his art. The submission process is tedious and potentially embarrassing: The academicians insist that artists, especially untried ones like Monet, undergo a harsh review that can be demeaning and demoralizing. Even if the artist is approved by the jury, the crowds and critics must weigh in with their opinions. It's like any struggle to get into a clique: If you try too hard, you may be ridiculed, but once the door opens, the true hazing begins.

The Door Opens

Monet waits five long years as he craves acceptance. In 1865, he submits two seascapes that fit the fashion of the Academy—they are large (35 x 60"); they are painted in the preferred somber palette and have been traditionally composed; they use refined detail. Both canvases are accepted and everyone responds enthusiastically. The critics and Monet's fellow artists are especially generous with their praise. **Little Oscar from Le Havre now becomes Claude Monet**, the bright young talent of the Parisian art world.

The Influence of Courbet

Priase for his work from the Realist painter **Gustave Courbet** (1819–1877) is especially meaningful to Monet, since, by the mid-1860s, Courbet is the grand old man of the avant-garde and a political progressive. In 1855, after having been rejected by the Exposition Universelle, Courbet had put up a tent nearby and displayed his paintings under the title *Pavillion of Realism*, effectively staging the art world's first one-man show.

A staunch advocate of the school of Realism, Courbet claimed that painting was "an essentially *concrete* art, and [could] consist only of the representation of *real* and *existing* things." In his belief that within the mundane realities of the here and now one finds epic qualities equal to the greatest stories of history, **Courbet made vast paintings of every-**

day subjects tinged with an awareness of social issues. His detractors claimed that Courbet was an *apostle of ugliness* and the "Antichrist of physical and moral beauty."

An unrepentant artistic rabble-rouser, the flamboyant Courbet created monumental paintings that captivated Monet. The latter believed that Courbet's rejection of the ideals of academic classicism (in which pre-ordained representations of beauty and harmony were deemed more important than personal inspiration) and his focus on capturing the events of daily life introduced the contemporary world into the world of art.

A Masterpiece begun—and abandoned

Feeling confident and daring after his success at the Salon, Monet begins *Luncheon on the Grass* in the summer of 1865. Before long, he is consumed by the painting, which proves to be an overly ambitious undertaking at 15 x 20 feet! *Luncheon on the Grass* is Monet's first work as a mature artist. The canvas is filled with the artist's handsomely attired friends. Bazille and Courbet are said to have posed for several of the male figures, and Monet's new girlfriend, **Camille-Léonie Doncieux** (1847–1879)—who would later become the first Madame Monet—is the model for all the women, who are captured at a moment when they are enjoying a sumptuous meal in a sun-dappled setting. Beautiful people lounging in luscious locales will become a lifelong theme for Monet, even if his own life is far from comfortable.

LUNCHEON ON THE GRASS (1863)
Édouard Manet
7′ x 8′ 10″ (2.13 x 2.65 m)

Musée d'Orsay, Paris. Erich Lessing/Art Resource, NY

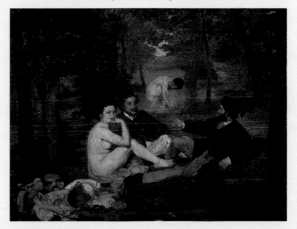

In 1863, Edouard Manet's *Luncheon on the Grass* was the *cause célèbre* at the first Salon des Refusés. Manet's subjecting of a classic subject—the nude and the artist in a landscape setting—to some contemporary twists provoked great distaste among the academicians and the public. Some scandalous highlights: The **sketchiness of Manet's technique** and the overall flatness of the composition infuriated the academicians. Within a few years, the same complaints would be leveled against the Impressionists. **The subject matter**—an incongruously nude woman sitting beside two men in contemporary dress and staring unabashedly at the viewer (nakedness aside, only a loose woman would look at you that directly)—made the more genteel members of the viewing public lightheaded. **Manet's painting and the Salon des Refusés** presented a new world of possibilities for artists, one in terms of painting style, the other in regard to exhibiting practices. Manet and the other rejected artists of 1863 took an important step toward wresting control from the Academy. The Impressionists would step in a few years later with the knockout punch.

OPPOSITE
Study for *Luncheon on the Grass*
1865–66. 58 x 80"
(130 x 181 cm)

In this painting, Monet attempts to combine heroic scale (à la Courbet) with painting outdoors. He hauls his easel off to the scenic environs of Fontainebleau and starts making sketches and studies. But the reality is that most of the work has to be done in the studio.

In selecting the subject of *Luncheon on the Grass*, Monet aligns himself with the avant-garde, given that his painting relates to Manet's masterpiece of the same name. The difference between him and Manet, however, is that Monet makes a gorgeous painting that does not offend bourgeois sensibilities. But his overreaching ambition—combined with a leg injury and rainy weather that inhibits his work outdoors— prevents Monet from getting a handle on this tremendous project (scale, color, subject, technique) and he soon realizes that he will not be able to submit it to the Salon of 1866. The abandoned painting remains a testament to Monet's unbridled youthful ambition. While working on the painting, Monet created a Study for the work, a Left Section, and a Central Fragment—all of which are shown here—and another section entitled *The Promenade.*

A Tall Tale and the Second Salon

Once again, Monet employs his mistress as model when he begins work on *Camille (Woman in a Green Dress)* in early 1866. Legend has it that, after abandoning *Luncheon on the Grass*, Monet submits *Camille*

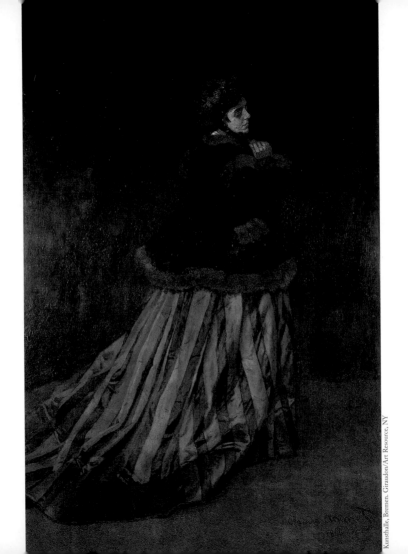

to the 1866 Salon jury at the last possible moment, following a four-day painting frenzy in which the entire—*life-size!*—canvas is conceived, executed, and finished. This impossible tale makes for good copy, and Monet shrewdly avoids setting the record straight. He knows, however, that it takes more than four days for an oil painting to dry and be transported safely.

Like the seascapes accepted by the 1865 Salon, *Camille* is painted in the richly dark tones popular with the jury. And, like *Luncheon on the Grass*, the canvas is quite the fashion statement: Camille's back is turned to the viewer, her face looking back over her right shoulder, and the composition offers the full effect of her beautiful frock and snappy fur-lined jacket. This dazzling picture helps to further Monet's career, even if the painting is criticized for its flat-footed treatment of the human figure.

OPPOSITE
Camille (Woman in a Green Dress) 1866. 103 x 67" (231 x 151 cm)

Sound Byte:
"Why, yes! Here is a temperament, here is a man in a crowd of eunuchs. Look at the neighboring canvases, how paltry they seem next to this window opened on nature. Here is an artist who is more than a realist; here is a sensitive and strong interpreter who can render every detail without becoming harsh."

—ÉMILE ZOLA, French novelist (1840–1902), on seeing Monet's *Camille*, 1866

The jury accepts *Camille,* along with one of Monet's Fontainebleau landscapes, and the painting becomes a huge critical and popular success. Both the progressive and the conservative press sing Monet's praises, and his father and aunt (who continue to provide the artist with much-needed financial support) are pleased by the **many predictions for his success**. It appears that a great career is his for the taking—but in fact, it will be decades before Monet can regularly afford the lifestyle that he covets already.

Dueling Ambitions

In the 1860s, Monet struggles with two sets of conflicting goals. On the one hand, he grapples with the tension between his loftier artistic ambitions and his more human **desire for material wealth**. The artists Monet admires believe that avant-garde painters must take risks and push viewers to accept the new (and the shocking), even if it's the

tried-and-true paintings that attract the crowds (and money). The experimental artist must play a highly tuned parlor game of biting the hand that feeds him and then convincing the owner of that hand that the latter has truly enjoyed the game. The **financially vulnerable Monet** tries to bite hard enough to be taken seriously by his avant-garde peers while being gentle enough to have his material needs met by collectors.

On the other hand, as Monet's submissions to the Salon of 1866 demonstrate, the artist is drawn to the bucolic nature of the earlier Romantic period—in which nature is featured in its pristine, unspoiled form—but at the same time is fascinated by the hip world of Paris. For the next decade, he alternates between these two subjects, often incorporating the best of both in a single work.

Garden Party Redux

In the summer of 1866, confident about his career, Monet rents a house he cannot afford in Ville d'Avray and begins his next big project, *Women in the Garden* (see page 33). It is a light-filled, life-size rendition (the large canvas is just shy of 9 x 9') of four women enjoying a flower-filled garden, dressed to the nines in their fetching summer frocks—the same dresses, in fact, as those shown in *Luncheon on the Grass*. Camille poses for all four women, and with the benefit of a

OPPOSITE
*Women in
the Garden*
1866
117 x 92"
(256 x 208 cm)

specially built trench-and-pulley system, **Monet works on the mammoth canvas outdoors**. Ever one to pursue his desires, he seeks to combine the grand scale of academic painting with the immediacy of painting in nature during the hours of brightest sunlight.

This enchanting scene ends late in the summer, however, when Monet and Camille run out of money and flee their creditors. They move to Honfleur, where the canvas is completed indoors. Alas, the jury at the Salon of 1867, unimpressed by this sumptuous beauty, rejects the canvas for being awkward and ill-defined. Suddenly, the newly exuberant painter, flush with success after the Salon of 1866, finds himself stalled, even though his friend Bazille agrees to purchase the work.

"Inventing" Reality

In 1867, Monet's respectable upbringing and his bohemian lifestyle collide when **Camille becomes pregnant** and Monet's father refuses to accept her into the family. If Monet does not abandon his mistress, Papa warns, the artist's allowance will be terminated. Faced with this threat and with no other prospects for supporting himself (much less a family), Monet abandons Camille and moves home to his family in Le Havre.

Whenever he is faced with emotional hardship, Monet creates for himself a fantasy world of safety and bliss. That's why the works from this Le Havre period reflect a tranquil outlook that bear little resem-

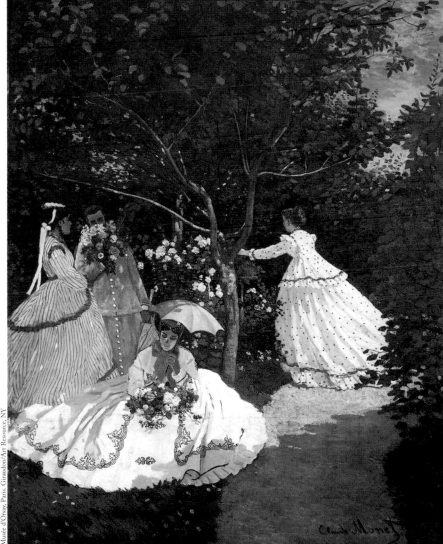

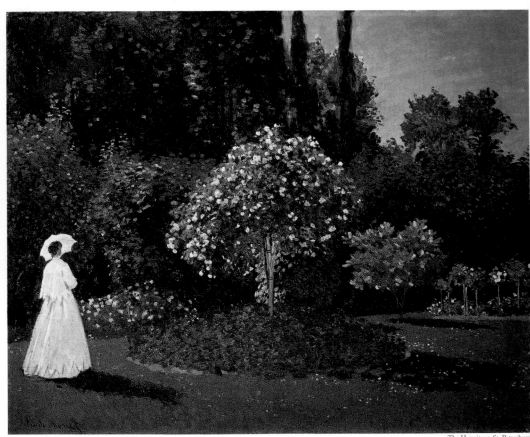

blance to the artist's personal reality. In spite of the depression brought on by his messy personal life and a bout with eye strain (from having worked too many hours in direct sunlight), Monet paints serene figures and happy pastorals, such as *Jeanne-Marguerite Lecadre in the Garden* (which features his aunt's great-niece) and *Garden in Bloom* (see page 16). Some critics have complained that Impressionist works tend to be "too pretty" and "escapist," but when you see paintings such as the latter, you can tell that the notion of *escape* is very much on the artist's mind in 1867. Throughout his life, whenever trouble rears its ugly head, Monet's response is always the same: Work like a maniac and produce beautiful, perfect moments.

A Big Transition

The most notable painting from this summer is the ambitious and compositionally radical *Terrace at Sainte-Adresse* (see next page). Despite the tension that exists in his family, Monet features his cantankerous father prominently in the lower front of this canvas, which documents a pleasant family holiday. Monet calls this work his "Chinese painting with flags," in reference to its Japonisme-inspired composition. (Note: Japanese and Chinese cultures were thought of interchangeably in Monet's time as being synonymous with "oriental.")

Terrace at Sainte-Adresse is **an important transitional work**: Stylistically, it lies on the border between a free, perceptual realism and

OPPOSITE
*Jeanne-Marguerite
Lecadre in the
Garden*
1866

OVERLEAF
Terrace at Sainte-Adresse. 1867
38 ⁵/₈ x 51 ¹/₈"
(98.1 x 129.9 cm)

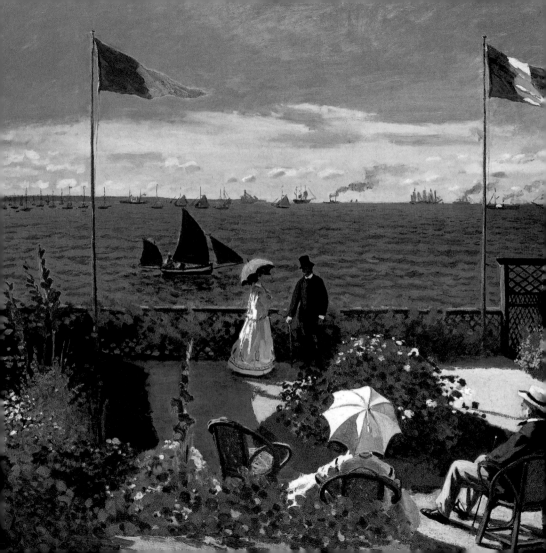

Monet's developing Impressionism. Combined with the father's downward-looking view, and the structural emphasis provided by the flags and the balustrade, the angular position of the father's rustic chair sets him apart from the other, less significant figures (who include Tante Lecadre). The grayed blue sky is flatly painted, though the bright green-blues of the sea are laid in with freer brush strokes. Against this background, the profiles of sailboats and ocean-going vessels appear as thin silhouettes. It is especially in the flower gardens that Monet, by intensifying a treatment used in other subjects of the same period, prefigures Impressionist handling by separating the color tones of blossoms, leaves, and shadows, restating their appearance in patches of bright red, green, yellow, and violet. In his effort to capture the full range of outdoor color, Monet is led by motifs, instinct, and experiment, and not by theoretical principles.

The Refrain of the Starving Artist

Camille gives birth, alone and in desperate poverty, to **Jean Monet** on August 8, 1867. Monet returns to Paris for the birth, and, in a letter to Bazille, expresses surprise at the love he feels. But this newfound paternal sentiment is not strong enough to battle the power of his disapproving, allowance-

37

TOP
*Madame
Gaudibert.* 1868
96 x 61"
(216 x 138 cm)

BOTTOM
La Japonaise
1875–76. 103 x 63"
(231.6 x 142.3 cm)

wielding father, so Monet heads back to Le Havre after a mere four days. Desperate to receive help for his new family, Monet sends imploring letters to Bazille (who becomes Jean's godfather), asking for food and money. Bazille, who is already making monthly payments of 50 francs toward his purchase of *Women in the Garden*, sends even more cash.

Some Precarious Moves

The Salon of 1868 rejects one of Monet's seascapes but accepts another (which is now lost). In the spring of 1868, Monet finally accepts a modicum of responsibility by moving temporarily into an inn with Camille and Jean in Bennecourt, a small town on the Seine River, to the northwest of Paris. There, he paints *The River*, one of Monet's first works that can properly be described as an "impression."

This act of independence enrages his father, who terminates the financial stipend on which Monet has been surviving. Claude must now earn enough on his own to feed three mouths. In August, the family moves to Fécamp, but debts continue to mount. Monet writes pleadingly to Bazille, who does his best to help his desperate friend. In September, **Louis-Joachim Gaudibert**, a wealthy merchant in Le Havre, commissions him to paint portraits of his children and wife. The patronage brings a measure of financial security to the fledgling artist, who joins his wife and son up the coast at Etretat, where they have taken lodgings. It is a time of joyful calm for the new family.

FYI: Japonisme—This is the name given to the craze for all things Japanese that swept avant-garde circles starting in the mid-19th century. Japanese arts, crafts, and especially prints influenced the Impressionist artists, who adapted their characteristic unmodulated color, striking outlines, flattened and foreshortened perspectives, and asymmetrical and abruptly cropped compositions to their own uses.

Sound Byte:

"I was just kicked out of the inn where I lived, naked as a worm.... My family refuses to do anything more for me.... I was so upset yesterday that I did a very stupid thing and threw myself into the water. Fortunately no harm came of it."

—CLAUDE MONET, to Frédéric Bazille, 1868

The cold and snowy weather inspires the nature-loving, art-world-weary Monet to paint a series of landscapes, including *The Magpie*, which capture the season's quiet yet intense light. In order to remain outdoors for hours on end while creating the work, he covers himself in a trio of overcoats.

Artist on the Verge of a Nervous Breakdown

The Salon of 1869 rejects *The Magpie* and another canvas, which leaves Monet feeling surly and unable to work. In addition to undermining his confidence, the rejection exacerbates his anxiety about the family's dangerous lack of income.

The Magpie
1869
40 x 58"
(89 x 130 cm)

Monet vents his frustrations on Bazille ("we have no bread, wine, fire or light"), who decides it is time to suggest ways for Monet to economize ("chop your own wood; walk to town instead of taking the train; drink local wine"). Monet, of course, refuses these suggestions and continues to beg for money and art supplies.

During the Salon, a dealer displays one of Monet's studies of Sainte-Adresse in his window, and it causes a furor among his comrades. Boudin writes of the piece's impact: "Its shock and violence have gained Monet a frenzied following among the young."

Painting Alongside Renoir

In the poverty-stricken aftermath of his rejection by the Salon, Monet uproots his family yet again, finding a cottage in Saint-Michel, a hamlet on the left bank of the Seine, near Bougival. The new home has the benefit of being located near Renoir, who offers the family food from his own table.

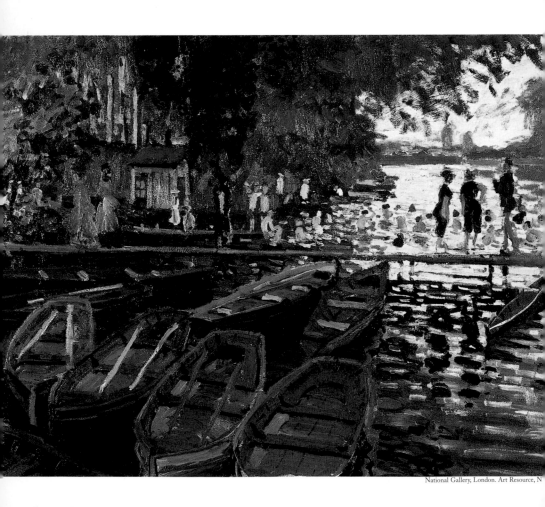

The summer of 1869 is just like old times, as Monet and Renoir work side by side once again. The bonding ritual of painting together has always been good for Monet, but this summer is exceptional in terms of its historic importance. Renoir's *La Grenouillère* and Monet's *Bathers at La Grenouillère* both capture an enchanting afternoon at a popular summer hangout for working-class Parisians. Monet and Renoir paint remarkably similar impressions of the lively floating party. For Monet, who produces several sketches of the location but never the full-scale saga he envisions (Renoir will make the locale famous in his *Luncheon of the Boating Party*), the work is a turning point in stylistic terms. The loose brushstrokes, the abstracted patterning of the water, and the spontaneity of the roughly sketched figures give Monet's paintings an impromptu quality that moves away from the highly finished and tightly composed pictures he is used to making (and selling).

Rejected and Angry

Monet's two 1870 Salon submissions, including a now-lost version of *La Grenouillère*, are rejected. With this slap in the face, Monet, the once eager-to-please young student, turns his back entirely on the Salon. And he has momentum on his side, too: The jury's decision to reject Monet's work causes an uproar, and several jury members, including Corot, resign in protest.

This is a key turning point in art history, since it arouses the rejected

Prussian Chancellor **Otto von Bismarck** (1815-1898) suggests ominously that, in his effort to unify Germany, he might influence the succession of the recently vacated Spanish throne. This would leave France isolated and vulnerable on its southern border. Most of the French are stunned when the dictatorial **Napoleon III** declares war on Prussia in July 1870. Prussian troops invade Paris and stay until January 1871, when peace is reached. France suffers a humiliating defeat in a mere six months and a lack of confidence in the government causes civil unrest to continue. This prompts a group of Republicans and members of the National Guard to form a provisional government ("the Paris Commune"), which lays the groundwork for civil war. By May 1871, the Commune is shut down and a bloodletting is underway. Thousands lose their lives.

artists to take a stand against the rigid Salon by staging an alternative exhibition (recall the Salon des Refusés). It will take many years for this initial protest (which we'll discuss in a moment) to bear fruit, but when it finally does, the Academy will never recover, and, in the process, the way art is created and perceived is radically transformed.

A Honeymoon in Trouville

On June 28, 1870, Claude and Camille finally marry in a civil ceremony in Paris, followed by an extended honeymoon and painting holiday at the Hôtel Tivoli in Trouville. Though besieged by worries about money (he is unable to pay his hotel bill) and by distress over the death of his beloved Tante Marie-Jeanne, Monet perseveres despite the hardships. His tunnel vision about money and work drives him to create nine paintings over the course of the summer.

Trouville faces the English Channel and features sandy beaches that Parisian day-trippers love. Monet feels at home in this touristy environment and his contentment shines through in works such as *L'Hôtel des Roches Noires, Trouville*, filled, like the other works of this time,

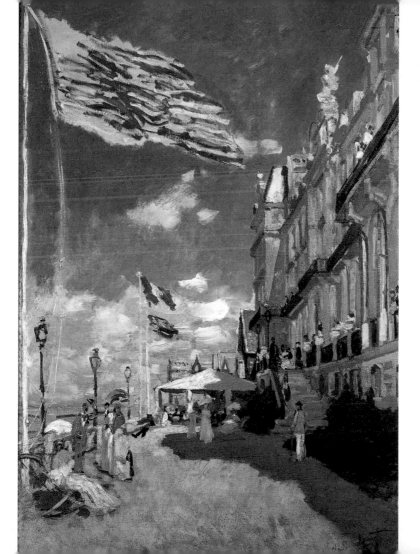

*L'Hôtel des Roches
Noires, Trouville*
1870

with lovely views, sunny landscapes, appealing waterscapes, and the beautiful people Monet loves to capture in their moments of leisure.

Draft Dodging

Paul Durand-Ruel

To avoid being drafted into the army during the Franco-Prussian War, Monet flees to London in the fall of 1870, where he paints less than usual, but achieves great things in two crucial areas. First, he makes important social connections. The expatriate artist Daubigny introduces Monet to the dealer **Paul Durand-Ruel** (1831–1922) with the words "This is a man who will be greater than any of us." Time and again over the next few years, Durand-Ruel will rescue the Monets from poverty. Second, the London trip offers Monet the occasion to study the works of English painters **John Constable** (1776–1837) and **J. M. W. Turner** (1775–1851). These atmospheric landscape painters greatly influence his technique, and he sets about painting the water and sky in some early versions of what will emerge beautifully three decades later in *Houses of Parliament and Thames River* (see page 98).

A Depressing Homecoming

To Monet's great horror, Bazille is killed in battle on November 18, 1870, and this puts a personal face on the gruesome tragedy of war. The following year, he hears that Courbet has been shot by a firing squad in Paris (which turns out not to be true). Monet's return to

France in the fall of 1871 is deeply painful. Not only has his father died during Monet's exile, which leaves the artist feeling orphaned, but Paris is in a shambles from the war—devastated, demoralized, and in the midst of a major reconstruction. Lost in a city he no longer recognizes, Monet departs in December for the town of Argenteuil, just downstream from Paris on the Seine River, near many of the sites where he had painted in the 1860s. Even though Monet feels gloomy about life, the heyday of Impressionism is about to begin.

Camille Monet
1871

Impressionism hits its Stride in Argenteuil

Argenteuil becomes Monet's base for seven years—his first stable home as an adult. Here, he finds new subjects in the postwar industrial frenzy that develops in the wake of the Franco-Prussian War. *The Railroad Bridge at Argenteuil*, for example, is a study of a contemporary moment, fixed in time, that depicts the encroachment of industrializa-

tion on idyllic countryside locales such as Argenteuil. Like many other towns that are growing larger through suburbanization, Argenteuil is home to a wide range of industry. The town's waterfront and proximity to Paris make it simultaneously a working port and a leisure destination.

Sound Byte:
"I have chosen the modern epoch because that is what I understand the best and find the most vital for living people."
—CLAUDE MONET, to Frédéric Bazille, 1868

A Moment of Prosperity

OPPOSITE
Wild Poppies
1873
19 ⅝ x 25 ½"
(44.1 x 57.4 cm)

The sale of 38 paintings between 1872 and 1873 leaves Monet feeling extravagantly prosperous. Twenty-nine of these go to one buyer: Durand-Ruel. With his new dealer's support and encouragement, Monet's prices increase and he has high hopes that the precarious lifestyle he has lived for so long is a thing of the past.

Paintings like *Wild Poppies* illustrate the serenity (for real this time!) of his home life during this period, as Monet lovingly merges the richly colorful landscape with his family, Jean and Camille. The latter, always vital parts of the artist's repertoire, make frequent appearances

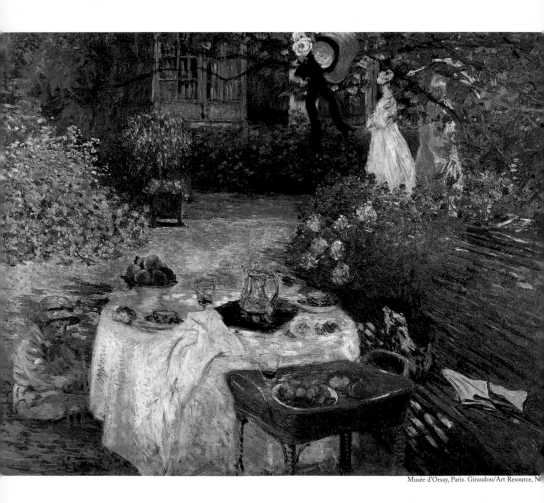

in paintings such as *The Luncheon*. At nearly 5 x 6 feet, *The Luncheon* depicts a bucolic afternoon during which, after a leisurely meal, Jean plays quietly with his toys while Camille and her guest take a turn around the garden. Life is beautiful and the flowers are lovely. While Monet may be closer to his materialistic dreams than ever, as witnessed by his bourgeois ideal of easy comforts, there is a loneliness or hint of ennui in this canvas that gives one a mildly unsettled feeling: It is as if all is not yet well in Monet's world, despite his desire for financial stability.

OPPOSITE
The Luncheon
c. 1873
71 x 89"
(160 x 201 cm)

A Renegade Exhibition

In the spring of 1874, Monet and his friends make a decision that will change the course of art history. After talking about it for seven years, the young artists finally give up all pretense of playing the Salon game. The tumultuous relationship between these artists and the Salon has included both rejections and acceptances. (Everyone but Degas had been rejected in 1867. In 1868, everyone showed but Cézanne.)

But the young artists are infuriated by the seemingly arbitrary judgments of the Salon jury. Rejection by the Salon damages an artist's reputation and ability to earn a living. Courbet, Manet, and the artists whose works have appeared at the Salon des Refusés have experienced sufficient success with critics, collectors, and the Salon to make them feel justified in their *right* to show and sell their work. They become

SIMILARITIES & DIFFERENCES AMONG THE IMPRESSIONISTS

The Impressionist painters had two things in common: (1) the shared experience of rejection by the academic system, which drew them together in the first place to show their work as independent artists; and (2) a desire to draw their subject matter from the contemporary world.

Edgar Degas was attracted to urban and intimate environments (think race tracks, dance studios, and brothels), which he depicted with precision and compositional brilliance. It is misleading to lump Degas with the rest of the Impressionists stylistically: He disagreed with the goal of painting quickly and literally, preferring instead to create carefully planned works that owed more to the cropping of photography and to Japanese prints than to Monet.

Pierre-Auguste Renoir loved the female body and the social locales of Paris. Rejecting the notion that the figure was of secondary importance to the capturing of instantaneous effects—au contraire, nudes are primary for Renoir—he combined the compositional examples of the Old Masters and of glowing colors in order to represent the beauty and sensuousness of the finer life.

Berthe Morisot focused on domestic scenes. Often painting outdoors, the artist shared with the Impressionists a love of brilliant light.

The American Impressionist Mary Cassatt (1845–1926) focused on mothers and children.

Paul Cézanne wanted to turn Impressionism into "something solid and durable," and painstakingly analyzed color, light, and form in his landscapes, still lifes, and portraits. Cézanne's profound obsession with the rigorous (and time-consuming) analysis of his subjects made him one of the most important early modern artists.

Camille Pissarro painted rural landscapes that features solid forms and high horizon lines. In the late 1880s, he adopted the Post-Impressionist technique of Pointillism, though he eventually returned to a freer painting style closer to Impressionism.

Sisley, like Monet, was a dedicated landscapist who remained committed to the Impressionist idiom.

the role models of this disenchanted group of artists who band together to establish an alternative show. In this defiance of the authority of the art establishment, the first cohesive avant-garde is born.

The Nerve!

The players hold their show in the swanky and conveniently located studio of the pioneer and controversial photographer **Nadar** (pseudonym of Gaspard-Félix Tournachon, 1820–1910, the French newspaper writer and illustrator who portrayed some of the most creative Parisians of his time). In a thunder-stealing move, their month-long First Exhibition opens on April 15, 1874, two weeks before the annual Salon, and is attended by 3,500 people. The variety of the works in the show—more than 200 of them—is enormous, the great majority being traditional paintings by little-known, Salon-rejected artists. There are, however, 50 entries by the core group of seven "Impressionists" (which they will soon be dubbed) and this constitutes the heart of the show.

Enough, Already!

The 15 instigators of this exhibition of the Société Anonyme des Artistes Peintres, Sculpteurs, Graveurs, Etc., include Monet, Pissarro, Degas, Renoir, Sisley, and Morisot. (Manet, Daubigny, Corot, and Courbet decide not to take part.) Monet understands the need for effective organizing in order to have a successful venture, and he

Claude Monet
1875

throws himself into it with great enthusiasm. The rules of this cooperative venture outside official channels are simple:

- Membership in the Société is open to anyone for an annual fee of 60 francs; the exhibition is open to all members.

- There is no jury. Space dictates how many works are included, and works are hung in only two rows—unlike the Salon, where getting one's work hung as high as the sky is every artist's mortal fear.

- There are no honorary awards. No government, commercial, or private funding is solicited for the venture.

- All proceeds are split evenly among the participants.

The show gets huge press coverage, even though the most often-repeated quotes are dismissive, as with critic Étienne Clarjat's scathing comment that the works of these artists offer "nothing but a defiance, almost an insult to the taste and intelligence of the public." Other critics, however, admire the work and praise the artists' daring; they call the show "a new road for those who think art needs more freedom." The Salon gets a good dressing-down, and critics praise the radical advances made by Monet, Pissarro, Degas, Renoir, Sisley, Cézanne, and Morisot in terms of their technique and style, as seen in their use of unfinished, loose brushstrokes. One critic calls Monet "the cleverest and most daring" of the group, and—thanks to one of Monet's submissions, *Impression, Sunrise* (see opposite)—the "group" soon become

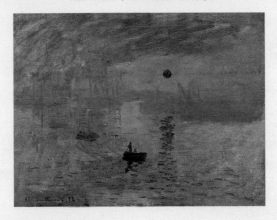

What, when, where: A misty sunrise seen from a hotel window at the harbor in Le Havre.

What else: Working boats starting the day's labor in an industrial seascape of smoke and clouds.

Why: To capture a fleeting daily event and to record an "impression" of what Monet saw.

Claim to fame: The title, an afterthought on Monet's part, is the real attention-getter. The critic Louis Leroy is credited with having coined the name "Impressionism" in his satirical mock conversation, entitled "Exhibition of the Impressionists," that he published in *Le Charivari* on April 25, 1874: "What does this canvas mean? Look at *Impression, Sunrise*. An impression, just as I thought. I said to myself, since I'm impressed, there must be some impression in it." Leroy's piece was published under the headline "Exhibition of the Impressionists." Yet, in retrospect, how few of the features that have been associated with Impressionism (concentrated sunlight, division of pigments with the color spectrum, etc.) are present here. Critic Jules Castagnary publishes a useful description of Impressionism four days after Leroy's article: "They are Impressionists in the sense that they render not the landscape but the sensation produced by the landscape."

known as Impressionists and this show is considered The First Impressionist Exhibition.

Aftermath of the Big Show

While the First Exhibition is not a financial success and none of Monet's works sell, the painter believes nonetheless that the furor raised by the show proves that he is on the right path. Delighted that his work may be playing a part in changing the art world, Monet returns to painting in an inspired frenzy of activity. That summer in Argenteuil, he completes more than 30 canvases, a record-breaking number even for him.

OPPOSITE
*The Railroad Bridge
at Argenteuil* (aka
Le Pont Routier)
1874
23 ⁵/₈ x 31 ¹/₂"
(53.1 x 71 cm)

Sound Byte:

"If only Monet wanted to cure himself of the sickness of Impressionism, what a landscape painter we would have!"

—ARTHUR BAIGNÈRES, critic, in *L'Echo Universel*,
April 13, 1876

In *The Railroad Bridge at Argenteuil,* Monet again displays the vertical, Japonisme-inspired composition he used in *The Terrace at Sainte-Adresse.* In his earlier "Chinese painting," Monet had used two flagpoles to flatten space. Here, he takes advantage of the mast of the sailboat that juts up from the bottom of the composition. This mast, originating somewhere below the artist's feet, extends from the unseen shore, past a

sailboat anchored nearby, through the river, beyond the far shore, and into the sky, where, reaching the clouds, the tip changes from a natural wood color to a dark gray. Again, Monet draws attention to the way in which we perceive depth on a flat surface. The technique plainly shows how carefully planned these "impressions" really are, with a compositional brilliance that combines traditional tools with touches so subtle that their specifics often go unnoticed.

A Life of Serenity

Manet and Renoir are among the many guests in Monet's home over the summer of 1874. One can easily imagine the meals, flowers, wine, and hangovers the friends enjoy as they paint and discuss their newfound notoriety.

To capture his pleasant life along the river, Monet turns a small boat into a floating studio. From his comfortable aquatic vantage point, he floats about freely, searching for scenes such as *Regatta at Argenteuil.* This ingenious vessel appears in several paintings itself.

In fall 1874, still convinced that money will soon follow his critical success, Monet goes on a spending spree, moving his family to an even grander Argenteuil home, hiring a gardener to help with elaborate landscaping plans, and even employing a housemaid. He buys Camille new clothing, and these frocks appear in romantic paintings such as *The Promenade.*

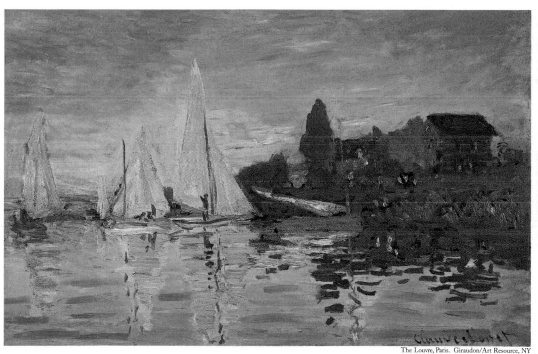

Regatta at
Argenteuil
c. 1874

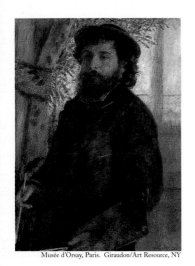

Pierre-Auguste
Renoir, *Portrait of
Claude Monet*
1875

Reality Checks

Money problems force Durand-Ruel—who has become the main source of the Monet's income—to cut back on his purchases in 1874. This causes the artist (and many of the other Impressionists) to scramble for new revenues. Renoir, Sisley, Morisot, and Monet decide to stage an auction of 73 of their works at the Hôtel Drouot in Paris in March 1875. The results are disappointing and debts begin to mount again. Monet launches into another round of pleading letters, now directed at Manet, who has stepped (or been forced) into Bazille's shoes. Two new collectors, **Jean-Baptiste Faure** and department-store owner (and sometime art critic) **Ernest Hoschedé**, help a little, but even when Hoschedé purchases *Impression, Sunrise* for the grand sum of 800 francs, Monet's income for the year is meager.

The Second Impressionist Exhibition

In April 1876, anxious to build momentum before their first success is forgotten, the Independents come together for a second show. Monet displays 18 works, including *The Luncheon, Bathers at La Grenouillère,* and

The Railroad Bridge at Argenteuil. The Second Exhibition receives more critical attention than the first, and while many of the opinions are barbed (such as Georges Maillard's contention that the paintings are "insanities of conception that are absolutely revolting"), the group has a growing number of fans among the press, and supporters such as the influential novelist Émile Zola.

Sound Byte:

"One cannot doubt that we are witnessing the birth of a new school. Incontestably, Claude Monet is the leader of the group."

—ÉMILE ZOLA, writing on The Second Exhibition, 1876

A Secret Love

Hoschedé asks Monet to paint four murals for a large room in his château in Montgeron, a six-month commission. One of the pictures is *The Turkeys*, a Japonisme-inspired work charged by sharply contrasting colors and a cropped, condensed composition that features white turkeys loose on the château's property.

The Turkeys. 1877
78 x 32"
(174.5 x 172.5 cm)
Musée d'Orsay, Paris. Erich Lessing/Art Resource, NY

After what turns out to be a potentially scandalous six months with the Hoschedés (more on this later), Monet returns to Paris and begins a series of paintings of the Gare Saint-Lazare, the huge, traffic-heavy train station in the capital's eighth arrondissement. For the population of Paris, still recovering from the destruction of the Franco-Prussian

War and the chaos of the Paris Commune, the Gare Saint-Lazare is a symbol of growth, power, and modern technology. Monet makes the station his own, painting a dozen views that range from its active interior filled with travelers, smoke, and a sense of expectation (*La Gare Saint-Lazare, Interior*) to the exterior tracks, which are more bleak, ominous, and solitary (*La Gare Saint-Lazare, Exterior, The Signal.*). An anonymous critic writing in the magazine *L'Homme libre* on April 11, 1877, writes that "Monet loves this train station. This station is full of din—grindings, whistles—that you make out through the colliding blue and gray of dense clouds of smoke. It is a pictorial symphony."

The Third Impressionist Exhibition

The 29 (!) pieces that Monet includes in the Third Impressionist Exhibition in April 1877 include *The Turkeys* and eight of the powerful Gare Saint-Lazare paintings. It is during this year that the group agrees to formally adopt the name *Impressionism*, so that their third group show becomes the first official exhibition of the Impressionists. This "label" implies that, in 1877 at least, the group is a cohesive unit, which would explain why the critics identify and discuss the group's "members" as a unified "school," even though, as we've seen already, this is not the case.

On the whole, the press is respectful, and the exhibition itself is seen as more professional than the previous Independent shows.

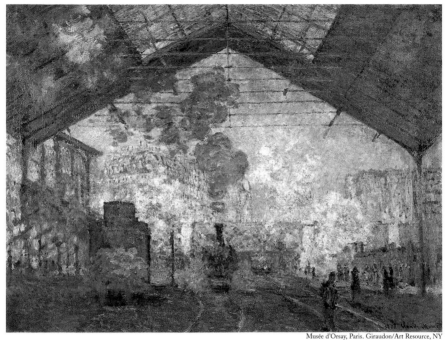

Alice and
Jean-Pierre
Hoschedé
Jan. 1, 1878
(probably
Monet's child)

Advertising banners appear throughout the city for the first time, and the opening is attended by more "well-dressed" people than in the past. The ultimate barometer is that attendance figures top 500 a day.

Leaving Argenteuil

Even though his fame is growing, money worries continue to plague Monet, whose cash flow never keeps up with his expenses. Things are so dire, in fact, that Monet fears losing his furniture to creditors. To make matters worse, a strain develops between Claude and Camille. She is pregnant and not feeling good, and Monet—never one to miss the pretty ladies—may have wandering eyes.

In January 1878, he settles a debt with his landlord and prepares to move once again. Part of the agreement requires that Monet leave as collateral his early masterpiece *Luncheon on the Grass*, and Monet feels he has hocked a major achievement of his youth for a less than promising future. (*Sad footnote*: The landlord rolls up the large painting and stores it poorly, which results in damage and mold growth. When Monet gets the work back years later, he is forced to cut off the damaged pieces in order to salvage what he can.)

Not One, but Two New Arrivals

On August 20, 1877, Hoschedé's wife, **Alice Hoschedé**, gives birth to a son. The baby had been conceived at the time when Monet was producing the mural at the Hoschedés' château, and almost immediately there are questions as to the paternity of little **Jean-Pierre**. (As an adult, Jean-Pierre will be known as Jean and will frequently comment on his Monet-like appearance.) Several months later, on March 17, 1878, Camille Monet gives birth to a son, **Michel**. Since the debt-ridden Monet lacks even the painting materials to continue working, he takes out his trusty pen and sends begging letters to everyone. Manet, the child's godfather, gets the most haranguing letters.

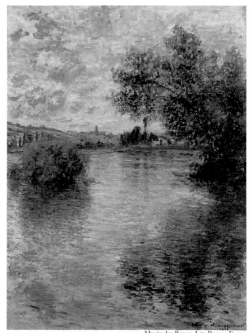

Musée des Beaux-Arts Rouen, France
Giraudon/Art Resource, NY

Musée d'Orsay, Paris
Erich Lessing/Art Resource, NY

ABOVE
Vétheuil
1879
LEFT
Chrysanthemums
1878. 24 1/4 x 29"
(54.5 x 65 cm)

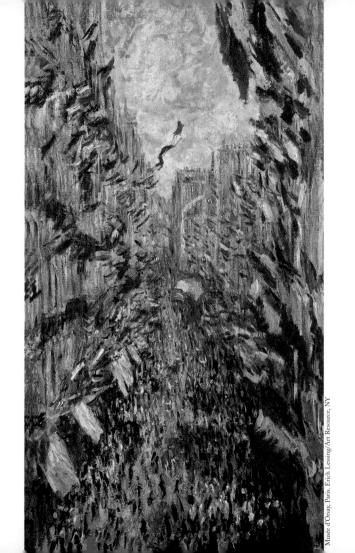

Ménage à Douze

In August 1878, the desperate Monet family moves to the small and sleepy town of Vétheuil, close to Paris. Vétheuil is hardly a refuge for bluebloods, but the formerly chic Hoschedé family, having lost their fortune for the second time in a decade (they lose their château and art collection), relocate to the same town as the Monets in an effort to economize. Ernest and Alice Hoschedé, along with their six children, agree to share expenses with the strapped Monet family by moving in with them—12 people in the same house! This bizarre arrangement is compounded by the questionable nature of Claude and Alice's relationship, and also by Camille's health, which has been failing since Michel's birth.

The unlikely troupe moves to yet another house at the end of the year. As usual, Monet torments himself by overworking. While Alice nurses Camille, minds the eight children, and tends to the household, Monet produces an amazing 300 paintings, including *Vétheuil*, along with occasional still lifes such as *Chrysanthemums* (see page 65).

The Fourth Impressionist Exhibition

At first, Monet decides to bypass the Fourth Impressionist Exhibition of 1879, since the "Impressionists" are increasingly mismatched and

*Camille on
her Deathbed*
1879
40 x 30 ¹/₄ "
(90 x 68 cm)

grumpy. He changes his mind, however, since he does not wish to be called a party-pooper. Instead, he exhibits an astounding number of paintings (29 of them!) in the show, two of which reflect his passion for flags. The press is particularly taken with *Rue Montorgueil,* painted in 1878 after Monet had walked along this street in Paris during the Fête Nationale of June 30, which celebrated the newly born spirit of patriotism of the post-Franco-Prussian War period. Monet had painted this canvas of the flag-draped street from a balcony above. (*Note:* "Montorgueil" is French for "mountain of pride.") His excitement is palpable in the interlacing sun and shadow, the windows, awnings, balconies, sidewalk stands, passing figures, and flying flags that fill both the street and the air above. One even sees "VIVE LA FRANCE" on the banner that spans the street. There are few works that illustrate better the dynamism of Impressionism, which is an art of movement as well as of light and color.

A Domestic Crisis and Its Aftermath

Monet's personal life overwhelms him in 1879. Camille, bedridden, is in constant pain and is diagnosed with cancer during the summer (they called it "a disease of the womb" in the 1870s) and Monet is greatly distressed about her and their two sons (Jean is 12 and Michel is one). She dies on September 5, at the age of 32. An anguished Monet paints a deathbed portrait of Camille, and is shocked to realize that he is preoccupied more with capturing the

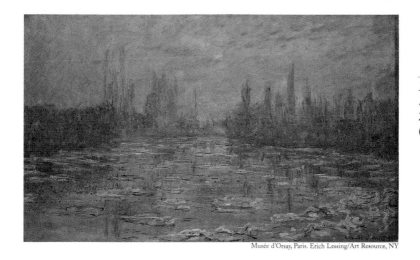

Ice Floes on the Seine. 1880
26 $\frac{1}{2}$ x 44 $\frac{1}{2}$"
(60 x 100 cm)

passage of light over Camille's lifeless face than with recording the sentiment of his lost love. As 1879 winds to a close, Ernest Hoschedé slowly withdraws from the rural domestic scene and spends most of his time in Paris, leaving his wife behind. In Hoschedé's absence, Monet paints a series of somber ice floes on the Seine, a reflection of his mourning and despair. This change in emotion is visible in the mournful *Ice Floes on the Seine*, a cheerless tableau of muted colors and brushstrokes. Gone are the happy, pretty scenes. Through dint of willpower, however, Monet succeeds in establishing a tenuous sense of normalcy at home, and thus begins painting the major works that will obsess him (and make him rich) in the 1880s.

Changing Alliances

The spring of 1880 finds Monet taking a controversial position when he forgoes the Fifth Impressionist Exhibition and submits instead to the Salon. He sees this as a pragmatic business decision, since the Impressionist group has already begun to disintegrate. Renoir and Sisley have already abandoned it, and, since Monet is now supporting a family of ten, he needs the Salon system to earn some real money.

Observers of the Impressionist group are not so kind. A sarcastic funeral announcement that appears in the newspaper *Le Gaulois* announces that "the Impressionist School has the honor of informing you of the grievous loss it has suffered in the person of M. Claude Monet, one of its revered masters." Readers are instructed not to attend the funeral, and the notice is signed "De Profundis," in behalf of the painters Degas, Caillebotte, and Pissarro, among other "ex-friends, ex-students, and ex-supporters." Monet fails to discover the identity of the culprit(s) behind this announcement. Thus, after being absent from the Academy's Salons for a decade, Monet submits two paintings to the Salon in 1880. True to form, the jury selects the "tamer, more bourgeois" (Monet's words) of the two and rejects the more Impressionist one—not an auspicious reentry for Monet, who grumbles that the accepted painting is poorly displayed and that the public response is lukewarm. This is the final time Monet subjects himself to the humiliating trial-by-jury system.

Taking Care of Business

Desperate to eek out some kind of financial stability, Monet decides to work with dealers other than Durand-Ruel, whose precarious finances continue to worry him. In a move that many consider brash and disloyal, the artist reaches an agreement to sell his works to **Georges Petit**, Durand-Ruel's major competitor. Pulling out all the stops, Monet decides that it is time to have solo exhibitions, and his first one-man show—held at the gallery of the magazine *La Vie Moderne* in June 1880—is a success. Buoyed by this favorable reception, and still angry about the Impressionist group's hostility toward him, he decides not to show in the Sixth Impressionist Exhibition in 1881. But Durand-Ruel coerces him to submit works to a different show—the Seventh Exhibition of Independent Artists of 1881—and the prolific Monet agrees to let 35 of his paintings be exhibited. While not a financial success, the Seventh Exhibition is generally considered to be a highly cohesive and unified Impressionist gathering.

The Great Campaigns

Having now reached his forties, Monet seeks new challenges. His weariness with the Parisian art scene and desire to be alone in nature manifest themselves in the kind of chronic wanderlust that art historians Robert Gordon and Andrew Forge call Monet's 1880s "Painting Campaigns," which feature long-term and labor-intense forays to remote locations. Between 1881 and 1882 alone, Monet takes extended trips alone to Fécamp, Pourville, Varengeville, Etretat, and Dieppe, producing a wide variety of new works in each of these locales, all the while sending detailed letters home to Alice. (During the first half of the 1880s, he completes more than 400 paintings, with water being the dominant theme.)

Sound Byte:

"He loves the water like a mistress."

—Émile Zola, May 24, 1868

One of Monet's favorite subjects from 1882 is depicted in *The Customs Officer's House at Varengeville*. The dramatic landscape and lush beauty of this naturally occurring gorge can be fully appreciated only by an artist who is "on location" and able to employ his sensory perceptions to capture the details of the scene's natural richness. The sturdy little customs house is isolated and vulnerable, yet possesses a timeless charm all its own.

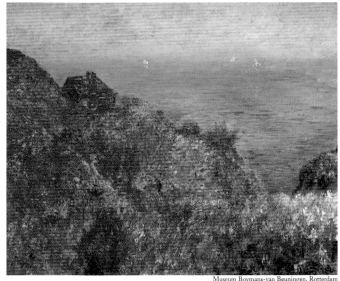

The Customs Officer's House at Varengeville
1882
26 $\frac{1}{2}$ x 34 $\frac{1}{2}$ "
(60 x 78 cm)

Museum Boymans-van Beuningen, Rotterdam

The **repetition** factor becomes a force in Monet's approach to painting during this period. Increasingly, he will paint multiple versions of the same scene, viewed at different hours of the day. Here, he paints 22 variations on the customs house, all of which prove highly popular with viewers. It is a time of exuberance for the artist, whose sudden freedom from the restraints of the Paris art world unleashes an energy of staggering proportions. It will become a period of tremendous growth and productivity for the traveling artist.

Deserting the Art World and Moving to Giverny

In March 1883, an exhibition of 56 paintings by Monet opens at Durand-Ruel. The critical response is cool, and the irascible painter blames his poor showing on Durand-Ruel's lackluster preparation for the exhibition. Nonetheless, Durand-Ruel proves yet again to be a savior in troubled financial times for the artist, helping Monet to settle Alice and the children in a new home in Giverny in 1883.

Sound Byte:

"When the public responds with silence and indifference, that is a non-success."

—Claude Monet, to Paul Durand-Ruel, 1883

The artist loves this new home so much that he decides to establish himself permanently there, thus foregoing his lifelong pleasure of moving back and forth between homes in Paris and the country. The rural nature of the setting appeals to Monet's need for tranquillity and natural beauty, and, with a few notable exceptions, he will spend the rest of his life painting out of doors, away from most people. In late April, Monet receives the devastating news that Édouard Manet is dead. He serves as a pallbearer at Manet's funeral.

The Mediterranean Interlude

On a whim, Monet and Renoir make plans for a ten-day trip to Bordighera, on the Italian Rivera, in December 1883. Monet's rapturous response to this environment is described in the two canvases that he completes in a week. In fact, the 43-year-old artist is so intoxicated by the locale that he returns in January 1884—without Renoir.

Having informed Alice that he will return to Giverny within a month, Monet instead stays on the road for four months. During this time, he claims in letters to Alice that a power stronger than himself draws him to the warm and beautiful Mediterranean. He assures her, however, that he is "living the life of a dog."

As always, Monet focuses on the landscape, not on the people or the customs of the area. In Bordighera, he finds a room, surveys his surroundings, and paints feverishly. His output is tremendous: 38 canvases, including *Villas at Bordighera* (see page 76), which profiles the more exotic features of the Mediterranean—its architecture, the agave plants, the distant mountains, and the brilliant light. Upon his return to Giverny, Monet is overjoyed to discover that the combination of his Impressionist style and exotic location appeals to buyers. For three years in a row, his earnings top 50,000 francs.

OVERLEAF
Villas at Bordighera
1884. 32 $\frac{1}{2}$ x 41"
(73 x 92 cm)

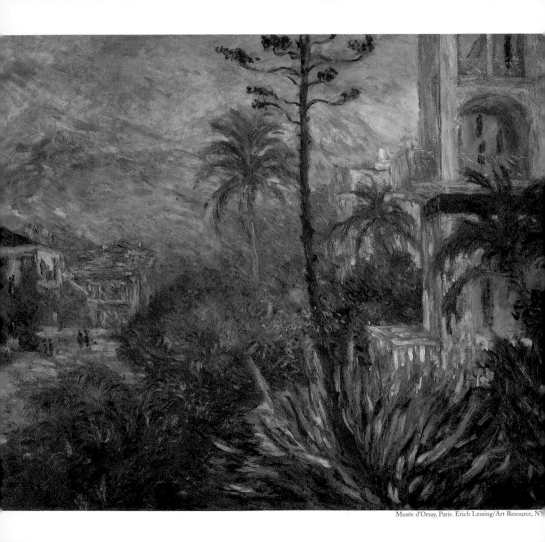

Tulip Season

In spring 1886, Monet takes a nostalgic field trip back to Holland, when the tulips are in bloom. There, he begins several canvases, including *Tulip Field in Holland* (see page 78), which features the expansive Dutch sky and, of course, a windmill. It is an instant Impressionist classic. When these paintings are unveiled in Georges Peit's Fifth Exposition Internationale in June, they are besieged by eager buyers, and Monet's income finally begins to keep pace with his grand expenses.

The End of the Impressionist Group

Sad but true: All good things come to an end. While the eight

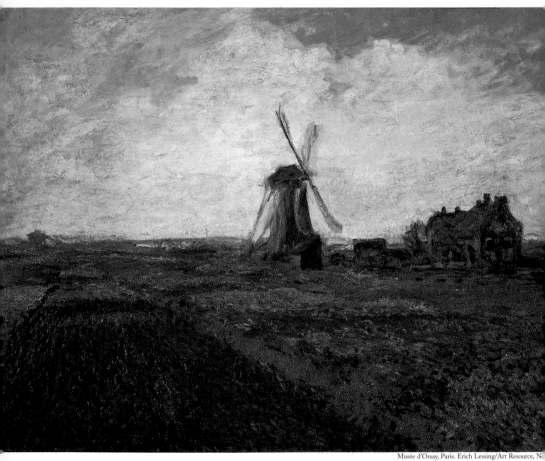

Independent Impressionist shows have changed the course of art history as it was known, the artists involved are known for their infighting, backbiting, and Machiavellian power struggles. As the years pass, the rebellious young artists have become increasingly popular, affluent, and famous. In short, they are now part of the establishment.

OPPOSITE
Tulip Field in Holland. 1886

Sound Byte:
> *"Our little temple has become a dull schoolroom."*
> —CLAUDE MONET, 1880

By 1886, the original group has largely disintegrated, and any freshness or surprise in the exhibitions comes from younger artists, who seek to

***FYI:* Neo-Impressionism and Pointillism**—Neo-Impressionism was both an outgrowth of and a response to Impressionism. The Neo-Impressionists sought to take Impressionism to the next logical level, which was to make impressions of nature more rational and scientific. Georges Seurat's Neo-Impressionist technique of Pointillism employs distinct dots of color that are "blended" by the viewer's eye rather than by the hand of the artist on the canvas. This method raises the stakes in the optical challenge inaugurated by Impressionism. To clarify his point, Seurat tauntingly argues that while Monet makes "a passing impression of reality," he—Seurat—prefers to "break reality down to pieces."

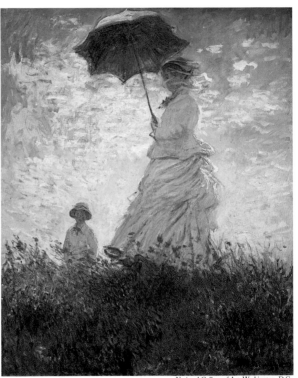

move beyond Impressionism. A fine example of these new avant-garde artists—known collectively as Post-Impressionists—is **Georges Seurat** (1859–1891), important for his firebrand Neo-Impressionist painting style known as *Pointillism*. Monet's friend Pissarro jumps on the band-wagon when he pronounces that anything that is not Neo-Impressionistic is outdated and fatigued.

Déjà vu

The Independents have become so mainstream, in fact, that Monet chooses not to show in the Eighth (and final) Impressionist Exhibition in 1886. Thus, the era ends without the participation of one of its most important visionaries. As the critical tide shifts from Impressionism to Post-Impressionism, Monet finds himself dream-ing of those glory years when he was at the epicenter of the Parisian avant-garde. (Ironically, a show of the Impressionists is held in New York in 1886 and proves to be an enormous popular and financial success.)

One afternoon in the summer of 1886, Alice's daughter Suzanne strikes a pose that eerily replicates that of Monet's late wife, Camille, in *The Promenade* (aka *Woman with a Parasol, Camille and Jean Monet*), a quintessential figurative work from 1875, made during his Argenteuil period. *Woman with a Parasol Facing Left* features an identical group of ingredients: parasol, white dress, blowing scarf,

OPPOSITE LEFT
Woman with a Parasol Facing Left
1886. 58 ¼ x 39"
(131 x 88 cm)

OPPOSITE RIGHT
The Promenade
(aka, *Woman with a Parasol, Camille and Jean Monet).* 1875
44 ½ x 36"
(100 x 81 cm)

and a similar vantage point. In its nostalgia, the new painting revisits the heyday of the now besieged Impressionist movement.

A Respite in Belle-Île

For his next painting campaign, Monet travels in October 1886 to Belle-Île, a remote and rocky island several miles off the coast of the Breton peninsula. Once again, he leaves behind Alice and the many children "for two weeks" (he stays on the island for three months).

Monet considers the isolated and windswept Atlantic coast of Brittany to be a "somber and terrible" place, but its rugged, intense beauty is the perfect antidote to his pensive mood. During his time there, he works in every kind of weather and produces 30 canvases, including *The Rocks of Belle-Île*. He returns to Giverny, lonely for its beauty and serenity, and in 1887 paints works such as *Boat at Giverny* that feature the Hoschedé girls boating on the Epte River. Notice the reflections of the three girls in the water, with the foliage behind them as a kind of tapestry.

Sound Byte:
"I feel I understand the sea better every day, the bitch. She is very terrible."

—CLAUDE MONET, to Alice Hoschedé, 1886

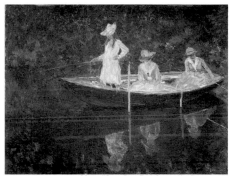

In 1887, eight of Monet's Belle-Île paintings are shown—to great response—at Georges Petit's Sixth International Exhibition. Theo van Gogh, the prominent art dealer/director at the firm of Boussod and Valadon and the brother of Vincent van Gogh (one of the upstarts who would undermine Impressionism), becomes one of many dealers now selling Monet's work.

Success...Sort Of

During a trip to the Mediterranean port of Antibes in early 1888, Monet recalls the success of his previous Mediterranean series and decides to create a cohesive group of paintings that focus on one subject, painted at different times of the day. In June, he sends ten of these to Theo van Gogh and the series is a huge success with the public. But

ABOVE LEFT
The Rocks of Belle Île. 1886

ABOVE RIGHT
Boat at Giverny
1887
43 ½ x 58 ¼"
(98 x 131 cm)

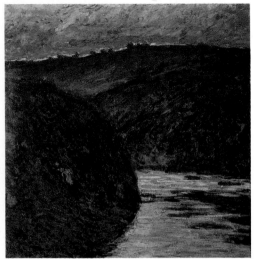

River Bend. 1889

his fellow artists and critics weigh in differently. Renoir describes the work as "retrograde," and others are equally harsh. Feeling unappreciated, Monet declines the French Legion of Honor and once again heads to the country, determined to show his adversaries the force of Impressionism.

The Creuse Valley

In early 1889, Monet is in the Creuse Valley, which lies in western France between the cities of Orléans and Limoges. There, he works on a series of two dozen pictures that includes such works as *River Bend*. The canvases have a strikingly uniformity; they are approximately the same size and are painted from the same vantage point. The Creuse Valley paintings, which constitute Monet's first formally cohesive series, exemplify the artist's fascination with the progressive observation of scenery over time. In the next

decade, he will revive this approach to create some of the most significant works of his career.

Finally Focused

By 1890, Monet has become a national treasure and he settles into a home life that has the solid, middle-class consistency of his father's dreams. That year, he buys the house in Giverny that he has been renting since 1883, and after living with Alice for more than a decade, he marries her on July 16, 1892. In 1893, he begins constructing his water garden.

A Series of Series

In choosing a single motif and painting it over and over again to show the passage of time and light, Monet invites his viewers to examine his subject in a new way: Through a series of closely related "studies," he gives them a greater opportunity to see *how* he is painting, rather than simply *what* he is painting. Process becomes more important than content. In interviews, he is fond of saying that he wishes he were born blind and suddenly given the gift of sight so he could paint the things revealed to him without any previous knowledge of them. The notion of an artist being able to see in a pure and unadulterated way—a kind of human camera—embodies the ideals of the Impressionists' goal of objectively recording the effects of light, color, and movement. Since

each these "series" paintings is produced as an ensemble, Monet insists that each series be shown in its entirety as a creative whole.

Monet is convinced that the concept of the series will prove, once and for all, the eternal vitality and complexity of the Impressionist aesthetic. He creates the first four series during an eight-year period of intense concentration, with subjects that include haystacks, poplar trees, and the Rouen Cathedral.

Haystacks Series

One day in the fall of 1890, while walking on the slopes above his house with his stepdaughter, Monet is attracted by a haystack that glows almost white, like a luminous spot, in the bright sun. But by the time he returns with materials and begins to paint, the effect has already changed. Seeing the light change, he dispatches Mlle Hoschedé to bring a fresh canvas from the house, and soon after she returns, he demands yet another. And so he continues the series, working on each version only when the particular effect returns. He finds the process a "continual torture.... It is enough to drive one raving mad, to render the weather, the atmosphere, the ambiance."

Monet puts aside a number of other projects in order to capture this only-in-winter moment. The *Haystacks* paintings (called the *Meule* series in French) vary greatly in size, but all have a profusion of intense

colors and consist of a simple composition, featuring one or two stacks in an open field—a scene familiar to the painter's fellow countrymen. Monet chooses this traditional, ordinary subject in part so that the viewer will focus on the **non-subject matters of light, composition, and technical mastery.** There are no distractions in these images and Monet uses them blatantly to display his new approach to painting.

Fifteen *Haystacks* are included in Monet's exhibition at Durand-Ruel's in 1891. All are sold within three days at prices ranging between 3,000 and 4,000 francs. Critics feel that he has succeeded in evoking in the *Haystacks* the mysterious power of the universe.

Sound Byte:

"You have dazzled me recently with those haystacks, Monet—so much that I catch myself looking at the fields through the recollection of your paintings."

—STÉPHANE MALLARMÉ, in a letter to Monet, July 9, 1890

Poplars Series

While taking yet another walk near Giverny, Monet is attracted by a magnificent stand of poplars growing in ordered sequence along the winding Epte River. After beginning to paint them, however, he learns that they are about to be cut down and sold at auction. The problem is solved, in

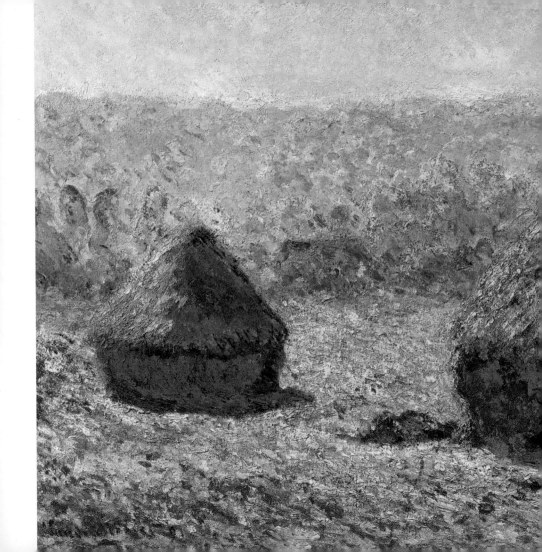

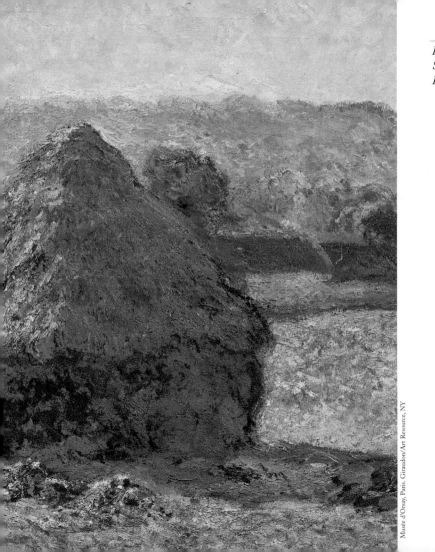

Musée d'Orsay, Paris. Giraudon/Art Resource, NY

Haystacks, Late Summer, Morning Effect. 1891

Monet's typically extravagant manner, when he agrees to pay the buyer a sum of money in exchange for the buyer's agreement to let the trees stand until the series of paintings is complete.

Using his trusty studio-boat to gain a water-level vantage point, Monet makes three compositionally distinct groups of *Poplars* (the *Peuplier* series in French), with a total of more than 20 paintings in the series. All are beautifully balanced images of the willowy, regulated trees through whose leaves the wind rustles mysteriously. In contrast with the *Haystacks*, the *Poplars* are more decorative and are painted in more dazzlingly harmonious colors. They are more elegant than the utilitarian and ground-hugging *Haystacks* and represent a kind of patriotic symbol (the poplar was considered a sign of liberty after the French Revolution).

The Four Poplars is a study in rectangles. Monet focuses attention on the lower sections of four tree trunks and their reflections, which divide the surface of the canvas into five vertical bands, and a horizontal strip that includes the bank and its reflection as a single area. The zigzag perspective of the distant trees is dissolved in opalescent light. By reducing the number of pictorial elements, Monet zeroes in on their placement within the square frame. The purity and iridescence of color are extraordinary. The many small dabs of color are distinguishable only when you stand close to the painted surface. As you move away from it, the colors blend quickly, like a mosaic of tiny beads.

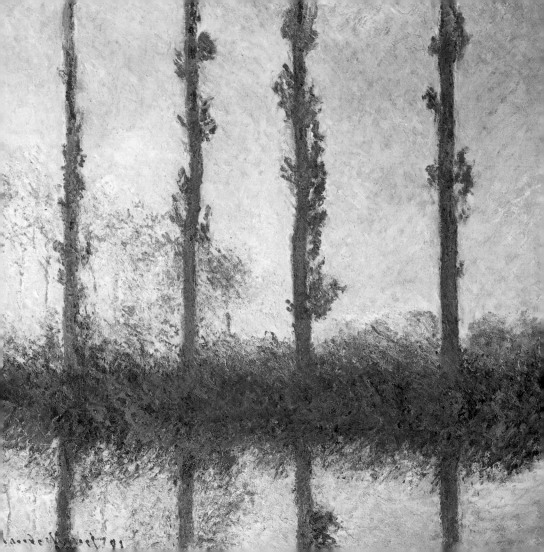

Rouen Cathedral **Series**

OPPOSITE
TOP LEFT
*Rouen Cathedral
Blue Harmony
Morning Sun*
1894

BOTTOM LEFT
*Rouen Cathedral in
Grey Weather*
1894

FAR RIGHT
*Rouen Cathedral
Full Sun*
1894

Four months before the opening of his first *Poplars* show in March 1892, Monet goes to the city of Rouen, where he sets up his easel in an empty hotel room across from the town's famous Gothic cathedral. Two visits to the site—during the winter months of 1892 and 1893—and a lot of work later in his Giverny studio produce an ensemble of 28 views of the cathedral's façade, viewed at various times of the day and under differing light conditions.

Changing canvases with the light, Monet follows the hours of the day from early morning, with the façade in misty-blue shadow, to the afternoon, when it is flooded with sun, to the evening, when the sunset weaves the weathered stonework into a strange fabric of burnt orange and blue. He even represents it in grey weather. As Monet paints it from across the square, with sky and ground cropped, the vertical piers, arches, and linking horizontals offer an enduring geometric skeleton to which the most fleeting of atmospheric effects can adhere. Monet demonstrates in this series that nature's color lies in atmosphere and constantly changing light rather than in inert materials.

It takes three years of difficult work to complete the series, and in a letter to Alice, he writes that the process is "terrible." In part, this is because Monet, lover of the flowing lines of nature, has a hard time painting architecture, with its manmade, unnatural surfaces. His room allows little movement or distance for viewing the progress of his

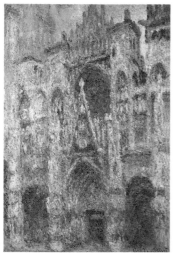

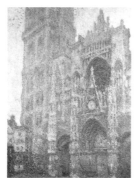

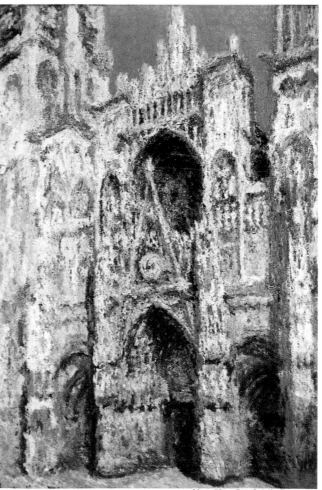

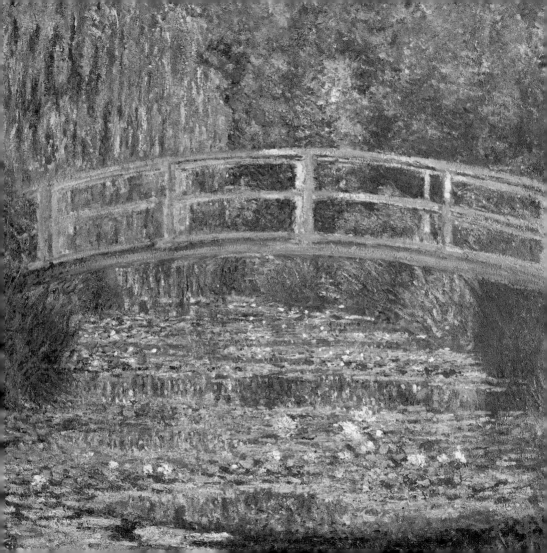

work, with only a single window as a light source and his only access to the subject.

How does your Garden grow?

In 1893, Monet expands his realm by purchasing the property adjacent to his home in Giverny. Flowers and gardening have been a lifelong passion, and now that he finally has the money to plan the ideal garden and hire a staff to manage it, he gives free rein to his goal of creating a floral paradise for himself. He sketches out an ambitious garden development plan, which includes building a new studio and a decorative bridge across the pond that will become home to his aquatic garden of water lilies.

The town becomes suspicious of all the activity going on over at the Monet compound, and there are complaints about rerouting water mains to suit the whims of the local celebrity. Predictably, Monet dismisses his neighbors' concerns and plunges into a passionate letter-writing campaign, which helps him obtain the necessary permits. After three different expansions, the water pond eventually covers an unbelievable thousand square meters, and the garden will be several times that size.

OPPOSITE
*Water-Lily
Pond, Green
Harmony*
1899
33 x 41 ¹/₄"
(74 x 93 cm)
Musée d'Orsay, Paris
Erich Lessing/Art Resource, NY

Sound Byte:

"I follow nature but I cannot catch her."

—CLAUDE MONET, 1889

Claude Monet
1900

Claude Monet
c. 1904, beside
the water-lily pond

When it comes to his gardens and his paintings, Monet—paint brush in one hand, trowel in the other—is a man possessed. In the flower and water gardens that he will cultivate for 33 years, Monet primps, prods, and fertilizes to suit his aesthetic and painterly needs, and he does so on a scale that reflects the grand scope of his ambitions. Planted with endless varieties of flowers and plants—including Japanese apples, bamboo, flowering cherries, rhododendrons, wisteria, and weeping willows—the garden, with its winding paths and enrapturing colors, takes on breathtaking proportions. As early as 1897, he has the vision of a round, seamless room covered with paintings of water lilies and floating flowers, which he calls the *Grandes Décorations*. In this, he imagines a monumental saga of nature, with the same scale and effect as his water garden. (Note: *Nymphéas* is French for water lilies.)

A Political Stand

During 1897 and 1898, France is in the throes of sorting out the painful repercussions of the Dreyfus Affair. **Alfred Dreyfus** (1859–1935), a Jewish captain in the French army, had been set up and convicted on rigged-up charges of spying for the Germans. (He is set free in 1899 and cleared of all charges in 1906.) There ensues a national crisis that revolves around the issues of patriotism and anti-Semitism, with parties pro and con dividing France into two camps. While Monet tries to stay out of the fray, many of his friends get involved. Renoir and Degas, increasingly conservative, take

a hard line against Dreyfus, while Monet's old friend, the novelist Émile Zola, shakes the entire nation with his famous article "J'accuse," which appears in Georges Clemenceau's liberal newspaper *L'Aurore,* and accuses the authorities of corruption. The article is an open letter to the president of the French Republic, bravely denouncing the acquittal of Count Charles Ferdinand Walsin Esterhazy, who, evidence later proves, is the one responsible for the acts of treason falsely pinned on Dreyfus.

Émile Zola

London Calls

Monet decides that his voice must be heard. Mindful of the power of his name and reputation, Monet makes public his support of Dreyfus in January 1898 by signing *L'Aurore*'s petition demanding the truth about the cover-up. Zola, charged with and convicted of libel, flees to London to avoid imprisonment, and in September 1899, Monet goes to England to visit him and to paint.

After settling into the luxurious Savoy Hotel with Alice and her daughter Germaine, Monet launches into a series of paintings that feature the Thames River and the Houses of Parliament, just as he had done in 1870. The balcony of his fifth-floor room directly overlooks the panorama of the fog-soaked river, with its diffuse, blurry atmosphere. (On and off, over a period of four years, Monet creates almost 100 paintings of this scene. When 37 of them are exhibited in 1904, there is a stampede of ready buyers.)

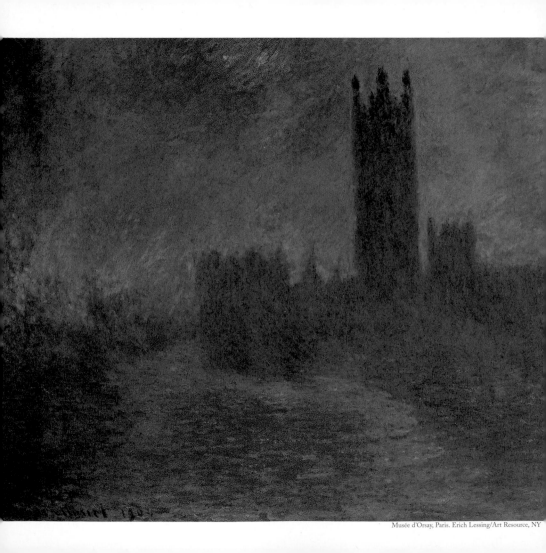

Water, Water Everywhere

By the turn of the century, the once-social Monet has settled into the quiet life of a small-town patriarch. He begins painting the water garden, which features his new Japanese bridge. The canvases contain rich scenes of the bridge, water, sky, and plant life. In *Water-Lily Pond, Green Harmony* (see page 95), the bridge functions as a gently curving abstraction, a human geometry imposed on nature. It dissects the image—water below, air above, and flowers everywhere—in a claustrophobic encroachment of plant life. For 27 years, he will paint a cycle of water landscapes devoted to the theme of peace and contemplation. The garden is Monet's final haven.

OPPOSITE
Houses of Parliament and Thames River Sun Breaking Through the Clouds 1904

Sound Byte:
"I am attempting things impossible to do: water with grass that undulates below the surface."

—CLAUDE MONET, 1908

In 1909, Monet opens an exhibition called "The Water Lilies, A Series of Water Landscapes," which includes 48 water garden paintings dating from 1903 to 1908. Painting only water, flowers, and air, the ultimate painter of nature has left dry land behind. The progression of

Monet's *Water Lilies* paintings can be summarized as follows:

- The earliest pictures retain a sense of scale and balance that allow them to be understood as traditional landscapes.

- With time, the paintings become progressively more abstract. Often the sky and the water seem to merge.

- Eventually, Monet abandons his horizontal, human-scaled canvases in favor of square, vertical, round, and enormous ones.

The Grand Old Master

From October to December 1908, Monet and Alice travel to Venice for what will be Monet's final painting journey. There, the 68-year-old artist paints on the canals and captures the shimmering water, air, light, and beauties of the palazzi.

After their return to Giverny, Alice is diagnosed with cancer and dies on May 19, 1911. The couple has been together for 30 years and Monet is devastated. In 1912, the Bernheim-Jeune Gallery exhibits 29 of his paintings, including several Venetian landscapes, which Monet describes as "souvenirs" of his last, happy trip with Alice.

Suffering from an advanced case of syphilis, Monet's oldest son, Jean, dies at age 46 in 1914. Monet's vision begins to fail and cataracts are diagnosed. While no action is required immediately, his sight deteriorates.

One Cranky Old Man

Monet is crushed by the losses of Alice and Jean. **Blanche Hoschedé-Monet,** the widow of Jean and the stepdaughter of Monet, becomes the painter's companion in his final years and is often the victim of his moods and tantrums. After an extended period of mourning for Alice and Jean, Monet returns to work with typically ferocious drive.

The changes in his life cause him to withdraw further from the public eye. He can no longer bear professional critiques of his work, and feels equally removed from the wheedling praises he now commonly receives. In a letter to the painter **Paul Signac** (1863–1935), Monet claims that, just as he has always been stoical about criticism (revisionism!), he feels "equally indifferent to the praises of imbeciles, snobs, and operators." In another letter from 1913, he fumes about the constant intrusions he suffers, conceding that people have the right to discuss his work, but that they should stay out his personal life.

A World War in the Backyard

France begins to arm itself for war during the summer of 1914. By October, people flee to the South of France to escape the encroaching madness. The 74-year-old Monet flatly refuses to leave his garden. By late spring 1915, Monet's idea of a gallery devoted exclusively to his water lily paintings consumes him. To accomplish this epic, he begins building a new studio with large skylights to compensate for his dimin-

OVERLEAF
Detail from
*Water Lilies
Study of the
Morning Water*
1916–26
Section of
quadriptych
each panel
7' 4" x 15' 7"
(200 x 425 cm)
Musée d'Orsay
Paris.
Erich Lessing/Art
Resource, NY

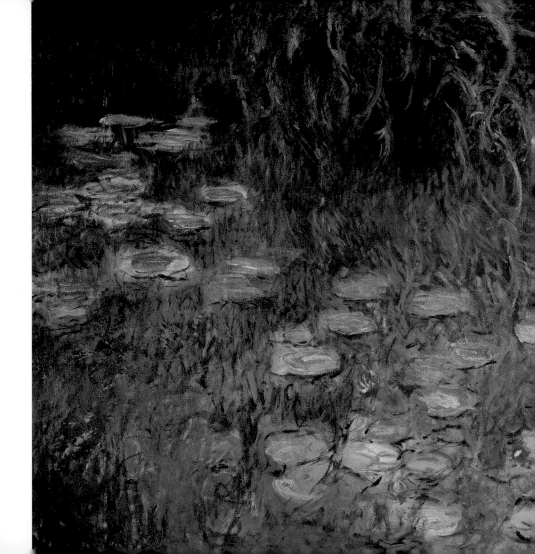

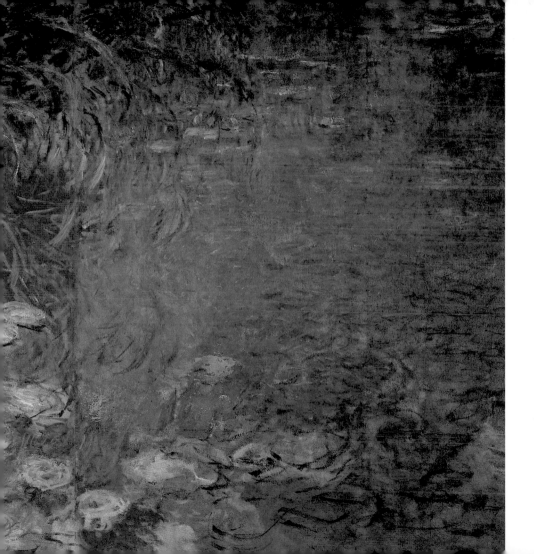

ished eyesight. Monet tenaciously ensures that the project is completed by 1916.

In the artist's late *Water Lilies*, the huge images of flowers and water begin to dissolve into each other, producing some of the most poetically harmonious paintings of pure color ever made.

A Modest Proposal

In the days before the Armistice in November 1918, Monet writes to his old friend Clemenceau, who is now the French premier, and offers a celebratory gift of two of his *Water Lily* panels to the nation. This modest proposal will occupy him for the rest of his life.

Self-Portrait
1917
31 x 24 ½"
(70 x 55 cm)
Musée d'Orsay, Paris
Art Resource, NY

Sound Byte:
"In this infinity, the water and the sky had neither beginning nor end. It was as though we were present at one of the first hours of the birth of the world. It was mysterious, poetic, deliciously unreal."
—RENÉ GIMPEL, art dealer, on seeing the *Grandes Décorations* lined up in Monet's studio, August 19, 1918

At the government's instigation, the two-panel gift grows overnight into an entire suite of decorations to be housed in a special oval building. The plan Monet has dreamed of for years now promises to become a reality, even though his eyesight worsens—which forces him to work indoors. A final contract for the gift of 19 *Water Lily* panels is signed in the spring of 1922 and stipulates that the paintings will be housed in two new oval galleries at the Orangerie, in the Tuileries gardens. The agreement guarantees that no other paintings or sculptures will ever be shown in the same space, and that, once hung, the paintings can never be moved.

Claude Monet
1922

Cataracts

Monet works and reworks his panels, forever fussing with their placement and redoing the paint. If he has a bad day in the studio, his entire household feels his wrath. The eye troubles worsen rapidly in late 1922, causing him anxiety about his ability to finish the project.

Sound Byte:

"At night, I am constantly haunted by what I'm trying to achieve.... The dawning day gives me courage. But my anxiety comes back as soon as I set foot in my studio.... Painting is so difficult."

—CLAUDE MONET, c. 1922

Having squelched all talk of eye surgery for several years, Monet acquiesces to the inevitable in January 1923. Two operations are performed during the first half of the year (a third will eventually be required, and Monet refuses a fourth). After a trying recovery period, he is encouraged as his sight improves, though it is far from perfect. Fitted with a special pair of corrective glasses, Monet returns to the studio and continues work on his *Grandes Décorations*.

The Last Stand

As the building to house his grand masterpiece nears completion, Monet loses confidence in his work. He is tired and grumpy, and feels old. He paints intermittently between 1923 and 1926, and at one point suggests that he begin the canvases all over again from scratch. Continued problems with his health and eyesight make the work slow-going—to the point where Monet abandons the project altogether. The French government and Clemenceau, who repeatedly sticks his neck out on Monet's behalf, refuse to release him from his obligation. He repeat-

edly falls into a depression, and does nothing for months on end. Just after his 83rd birthday, Monet's sight and spirits improve. In February 1926, he finishes the job—now numbering 22 canvases.

Death

Before the *Grandes Décorations* can be installed, Monet's health rapidly declines. In the summer of 1926, he works in the garden, but he does not paint. He has cancer and quietly grows weaker during the fall. One by one, in rapid succession, he loses the ability to paint, write, smoke, and eat. With Blanche, his son Michel, and Clemenceau at his side, Monet dies on December 5, 1926. His extended family buries him in Giverny in a private ceremony.

Sound Byte:
"I have painted directly from nature, seeking to convey my impressions of her most elusive effects; and I am aghast at being the cause of a name given to a group of artists of whom the majority were anything but Impressionists."

—CLAUDE MONET, 1926

Postscript

On May 17, 1927, the *Grandes Décorations* are unveiled as a continuous panorama in two rooms at the Orangerie, just as Monet had

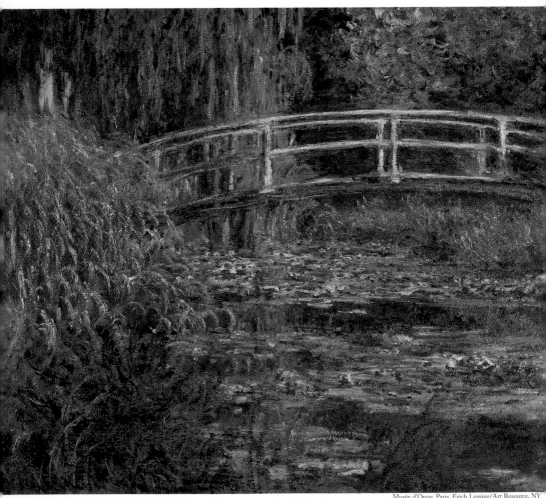

instructed. Today, this culmination of a brilliant career draws tens of thousands of visitors every year—which amounts to no less than a grand finale for both Monet and Impressionism.

The Nuts and Bolts of Impressionism

OPPOSITE
Water-Lily Pond Pink Harmony
1900. 40 x 44 ¹/₂"
(89.5 x 100 cm)

Impressionism, the 19th century's most innovative art movement, ushers in the era of Modern art. The Impressionists opened the door for many of the important artistic ideas of the 20th and 21st centuries, including pure abstraction. By attempting to render an impression of what the eye sees in a given moment rather than what the mind knows to be there, Impressionism shifts art-making from a craft-based skill to an intellectual inquiry.

Two key points to remember about Impressionism are that: (1) color is not inherent in objects; it is the reflection of light that imparts color to an object; and (2) the appearance of an object is constantly in flux, since light is transitory and is affected by atmosphere and time.

Monet was a man whose brilliance lay in the simple goal that compelled his enormous ego and ambition: He wanted to convey the beauty of a flower, a landscape, or a stunning dress exactly as he saw it when standing in front of it. He aspired not to idealize, but to render accurately the world around him.

Monet's Place in the Art Pantheon

OPPOSITE

TOP
*Water Lilies
at Sunset*
1916–26
7' 4" x 15' 7"
(200 x 425 cm)

BOTTOM
Water Landscapes
(first room) at
the Musée de
l'Orangerie
Paris
c. 1919–26
The painting on
the opposite page
can be seen at
the end of the
room in this
photograph

As generations of critics have marked their territory and hashed out the value of Monet's work in relationship to their own times (he's up, he's down; he's in, he's out), the public has remained constant in its love of his beautiful evocations of the natural world.

Of the many attitudes that formed Monet's art, two—the belief that whenever possible a work should be completed in full view of its subject, and the aspiration toward decorative mural painting—were often in conflict. When he attempted to adapt landscape or still-life subjects to a decorative scheme, or to enlarge easel pictures to mural size, he was usually unsuccessful, because the vitality of direct painting was lost. Though he may not have realized it at first, the creation of the water garden finally fused these goals. As a master gardener, he had created a motif that was both decorative and muralesque when painted directly. In the oval rooms of the Orangerie, one is surrounded—as was Monet in his sequestered garden—by a fluid universe at once limitless and enclosing. Described by the painter André Masson in 1952 as the "Sistine Chapel of Impressionism," the rooms present a new type of space and an unprecedented conception of a painted interior.

And the Winner Is?

In the years since their work was derided for being ugly and loathsome, the Impressionists (in particular, Monet and Renoir) have been sub-

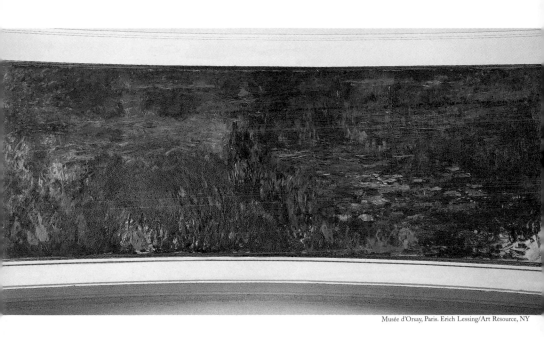

jected to a curious form of reverse discrimination. Over the years, a number of critics have declared their work too pretty, too decorative, and too lacking in content to be considered in the front ranks of innovation. But as their popular success in blockbuster exhibitions and in auction houses has shown, these artists are unquestionably the big winners in the art popularity contest.

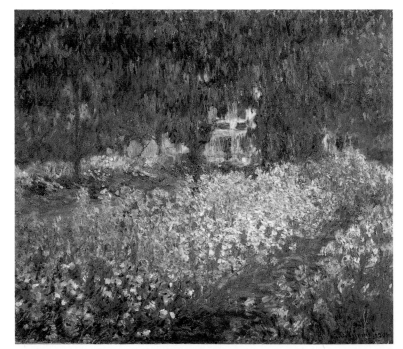

*Monet's Garden
at Giverny*
1900
31 $^{7}/_{8}$ x 36 $^{1}/_{4}$"
(72 x 81.6 cm)